The College History Series

FLORIDA ATLANTIC UNIVERSITY

D0880318

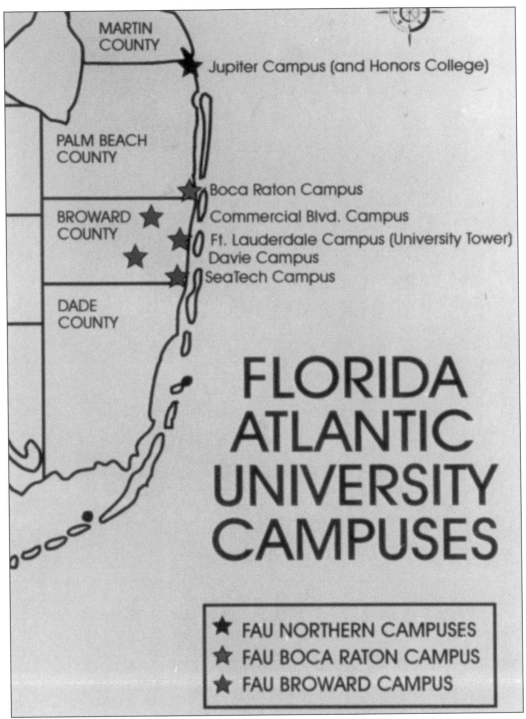

MARTIN COUNTY

Jupiter Campus (and Honors College)

PALM BEACH COUNTY

Boca Raton Campus

BROWARD COUNTY

Commercial Blvd. Campus

Ft. Lauderdale Campus (University Tower)

Davie Campus

SeaTech Campus

DADE COUNTY

FLORIDA ATLANTIC UNIVERSITY CAMPUSES

★ FAU NORTHERN CAMPUSES
★ FAU BOCA RATON CAMPUS
★ FAU BROWARD CAMPUS

This map shows the locations of FAU campuses in Palm Beach and Broward Counties.

The College History Series

FLORIDA ATLANTIC UNIVERSITY

DONALD W. CURL

ARCADIA

Published by Arcadia Publishing,
an imprint of Tempus Publishing, Inc.
2 Cumberland Street
Charleston, SC 29401

Printed in Great Britain.

Library of Congress Catalog Card Number: 00-105334

For all general information contact Arcadia Publishing at:
Telephone 843-853-2070
Fax 843-853-0044
E-Mail sales@arcadiapublishing.com

For customer service and orders:
Toll-Free 1-888-313-2665

Visit us on the internet at http://www.arcadiaimages.com

For Thelma Spangler, FAU's real historian.

CONTENTS

Acknowledgments

Many individuals made contributions towards the compilation of this book. Peggy McCall, the archivist of the Boca Raton Historical Society, supplied photographs of Boca Raton Air Base. Zita M. Cael and Nancine Thompson of the S.E. Wimberly Library Special Collections Department found historic photographs and slides from the permanent collection; Lynn Laurenti, Douglas Applebaugh, and Louise Hinton of Media Relations contributed recent photographs; and Mardie Banks and Kay Gutierrez of Learning Resources made the necessary copies of the old photographs and slides. I thank them all for their aid, knowledge, and unfailing good humor. Particular thanks go to Elfriede M. Lynch of University Relations and Alumni Affairs who never once flinched at my request for unusual photographs, nor came up short in their delivery. I especially thank her for using her unfailing knowledge of FAU to help validate the factual context of this pictorial history.

INTRODUCTION

The Florida legislature authorized a new state university for the southeastern section of the state in its 1955 session. From the onset, the old, almost abandoned, air base in Boca Raton seemed a perfect site for the new institution. While the legislature allowed the board of control, the governing body of Florida's higher education system, to begin planning, it failed to allocate any financial resources for the new school. Thomas F. Fleming Jr., founder of Boca Raton's First Bank and Trust Company (today part of Bank of America), both negotiated with the federal government to secure the title to the air base lands and established the Endowment Corporation to raise money for planning.

The board of control planning committee, headed by Dr. J.A. Brumbaugh, an authority on higher education, issued its "Brumbaugh Report" in June 1961 calling for an innovative institution that could serve as a model for new universities of the late 20th century. The report detailed an upper-division school of juniors, seniors, and graduate students designed to complete the work of Florida's extensive system of junior and community colleges. It also outlined a program that utilized media aids and electronic technology to free up time for the faculty, which was made up of "master teachers," for greater individual contact with students and more time for individual research projects. The technology included two television channels, a computer-run library, and student work stations wired for the reception of audio, television, and automated teaching devices.

Although the Florida Board of Education, at its May 9, 1960 meeting, approved the Boca Raton location and the building of the fifth state university (planned to open in 1964), the state legislature, under the control of Panhandle "porkchoppers," refused to vote for the necessary funds. Consultants determined that a university in southeastern Florida had the potential for 30,000 students. The "porkchoppers" wanted the university in Pensacola, though the potential student body barely existed. In order to open the school on schedule in 1964, the board of control mandated that the community raise at least $100,000 to pay for architects' fees, salaries, and other expenses.

When Farris Bryant became governor in 1961, he realized that all the state universities needed additions to their physical plants and called for $25 million in bonds to build the Boca Raton campus and construct needed facilities at other institutions. After a serious court challenge, the bond issue gained approval and the state sold the bonds in 1962. This gave the new university $5.3 million for construction.

With its financing secured, the board of control decided to give the school a name and appoint a president. The University of South Florida seemed a perfect name, except it had been taken by the state school in central Florida. "Boca U." had commonly been applied to the school, but the board wanted a name more representative of the south Florida area. Finally, at its May 1962 meeting, the board chose Florida Atlantic University (FAU) for its name, and appointed Kenneth Rast Williams, the founding president of Miami-Dade Junior College, as head of the new school. Williams arrived on campus in July 1962 and opened his office in the air base's old fire station.

During the summer of 1964, after two additional years of planning and building, the new faculty and staff began moving into their offices. The plan for a curriculum utilizing television and other experimental learning tools continued, though the new faculty soon realized that the state had no intention of providing adequate funding for the school's innovative program. Some state officials actually thought the innovations meant less costs, as fewer faculty members could teach more students by using television. As Roger H. Miller, the first dean of administrative affairs said in his memoir, "The seed of experimentation, rather than being nurtured was, from the very outset, treated like a bonsai tree, pruned to the edge of extinction."

The university planners said over 2,000 students would enroll for the first classes scheduled for September. Assured of success, there had been no effort made to recruit. Unfortunately, the university provided for no dormitories or places to eat on the original campus, and rooms and apartments in Boca Raton were both scarce and expensive. Moreover, there was no public transportation system and the south Florida road system was extremely poor. Interstate 95 did not exist, and Boca Raton's connection to the Sunshine State Parkway (today's turnpike) was a narrow two-lane road. Looking back, it's hardly surprising that less than 800 students chose to attend FAU in 1964.

The years that followed continued to be rocky. Enrollment problems plagued the university up into the 1990s. Funding for the university's programs (often linked to enrollment) remained inadequate as state legislators choose to build new universities rather than support those already in existence. Over the years, merger plans have threatened the university's very life, as does talk of establishing a new state school in Fort Lauderdale. Yet Florida Atlantic University has grown, in students, programs, degrees, faculty, buildings, campuses, endowment, and most importantly, pride and prestige. As the new century dawns, FAU can look forward to fulfilling its early promise as a truly regional university for southeastern Florida.

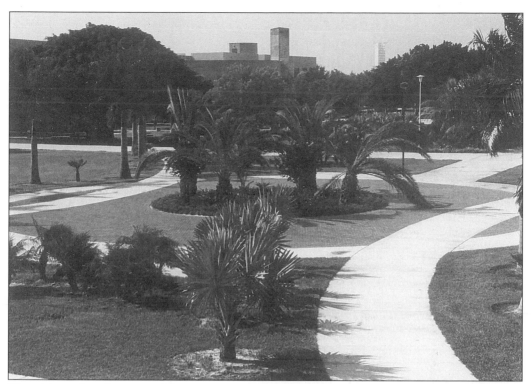

The old quad to the west of the Williams Administration Building received new landscapping and paving in the last years of the 1990s.

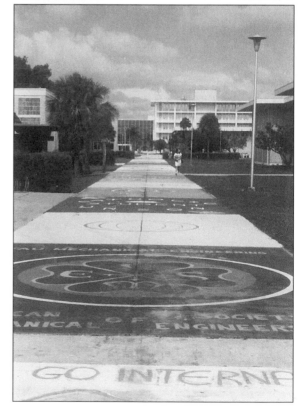

The long walk stretching from the dorms to the library became the traditional place to advertise a meeting or make your organization known to the world.

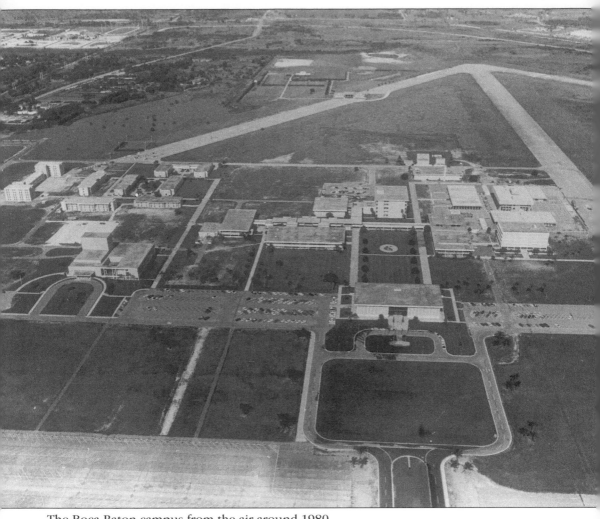

The Boca Raton campus from the air around 1980.

One
"WHERE TOMORROW BEGINS" (1955–1966)

Thomas F. Fleming Jr. provided the leadership that brought FAU to Boca Raton. Although Georgia-born, Fleming came with his family to south Florida during the land boom period of the 1920s. After graduating from Fort Lauderdale High School he attended the University of Florida and received an MBA from Harvard. He moved to Boca Raton in 1939 after his marriage to Myrtle Butts, the daughter of August and Natalie Butts. Fleming helped manage the Butts Farms. Later he became interested in property development and founded the First Bank and Trust Company.

He used his friendship with Congressman Paul Rogers and Senator George Smathers to make the contacts that secured the federal grant of land that eventually became the university. He also established the Endowment Corporation that helped support the school during its planning years and pledged that a minimum of one-percent of First Bank and Trust's pre-taxed earnings go to the endowment.

Finally, Fleming served as Lyndon B. Johnson's Florida chairman in his 1964 election campaign. This helped him secure President Johnson as the speaker at the university's dedication ceremony on Sunday October 25, 1964. Before a crowd of over 15,000 people, Johnson received the new university's first honorary doctorate.

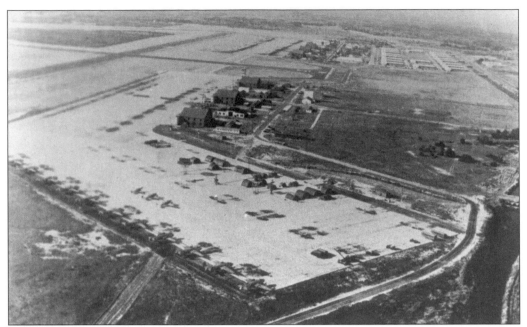

This is an aerial view of the Boca Raton Army Air Field, which opened in October 1942 as the Air Corps' only World War II radar training school. By January 1943 three 5,200-foot-long airstrips and more than 800 structures served 1,340 airmen trainees.

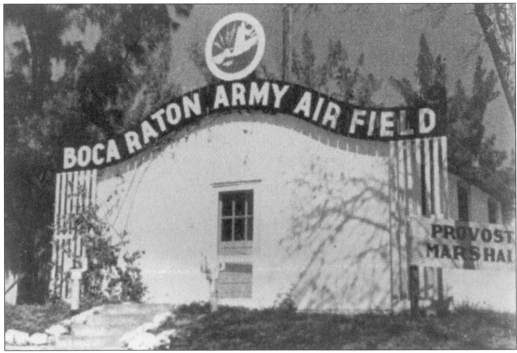

The entrance gate and provost marshall's headquarters for the Boca Raton Army Air Field was located near today's Palmetto Park Road and Northwest Fourth Avenue. The headquarters building for the air field still stands to the northwest of this intersection.

Some attempt to enliven the desolate Florida scrubland can be seen in the entrance gate built for the Nurses' Quarters at the air field. By 1945, 16,281 troops were enrolled in the radar and electronic courses offered at the facility.

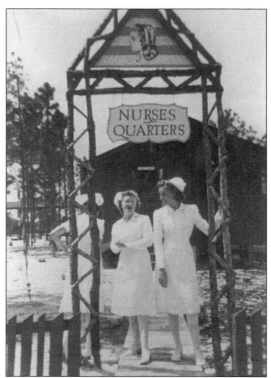

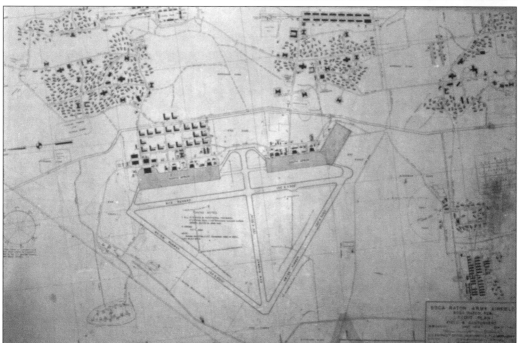

The extent of the air field can be seen in this layout plan. The parallel rows of dark buildings at the top center are warehouses located along the Florida East Coast Railway tracks. The base extended north beyond Spanish River Boulevard, south to Palmetto Park Road, and west into the area holding today's Interstate 95.

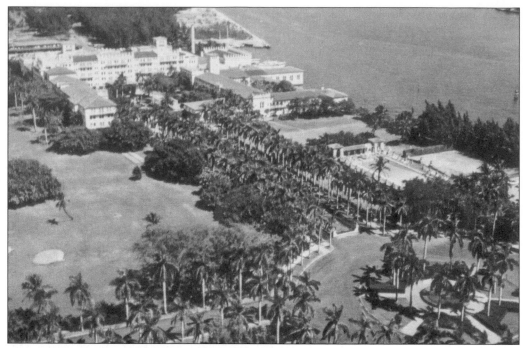

The Army Air Corps also took over the Boca Raton Club in 1942 to house the officers among the thousands of trainees. The employees of the luxurious club hurriedly stored the valuable antiques and elegant furnishings, substituting standard GI bunks in their place.

Theodore Pratt completed his best-known novel, *The Barefoot Mailman,* in 1943 while living in Old Floresta in Boca Raton. He and his wife, Belle Jacque (Jackie), are seen at the air field's open house in November 1945.

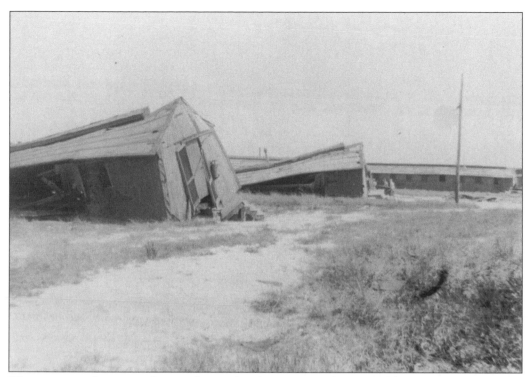

When a severe hurricane hit southeast Florida on September 17, 1947, many airmen at the Boca Raton base already had been transferred to their new radar training facility at Kessler Air Force Base in Mississippi.

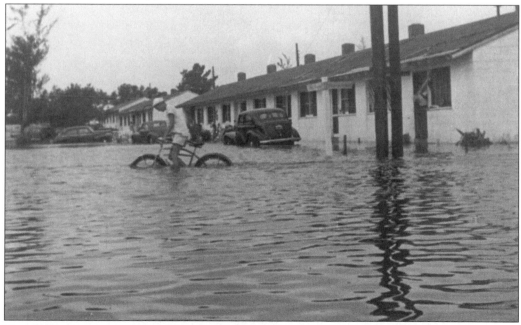

The 1947 storm caused extensive damage to the hurriedly built frame structures of the base and was responsible for widespread flooding. These conditions convinced the Air Force to abandon the site earlier than originally planned.

Local Boca Raton banker Thomas F. Fleming Jr. served as the founding father of Florida Atlantic University. Fleming belonged to the leadership fraternity of Blue Key at the University of Florida, as did Senator George Smathers and Congressman Paul Rogers. Fleming's friendship with these men helped pave the way that led to the Civil Aeronautics Administration's decision to release the air base's land for the purpose of founding the university.

The board of control appointed Kenneth R. Williams as the university's first president on May 11, 1962. The fifty-one-year-old educator had been born in Monticello, FL. He earned both his B.A. in education and M.A. degrees from the University of Florida and received his Ph.D. from the University of Chicago. He was serving as the founding president of Miami-Dade Junior College when he was appointed to the university.

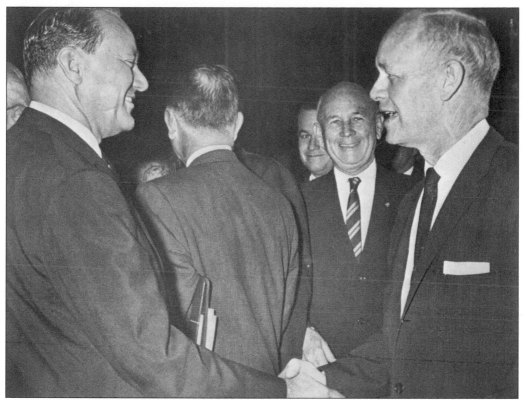

Over the years, Williams had served in a number of administrative posts at the Universities of Georgia and Florida, and as president of Florida Junior College. Rumor claimed that Governor Bryant supported him for the presidency of the new university. Byrant had known Williams's wife, Selma, since childhood and the two men became friends during Williams's tenure at Florida Junior College in Ocala, which happened to be Bryant's hometown.

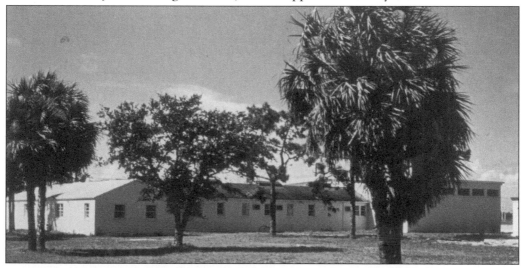

The air base's firehouse served as the first temporary offices for President Williams and his staff, which included media representative Adelaide Snyder and executive secretary Barbara Rich. One reporter called the building only "slightly remodeled."

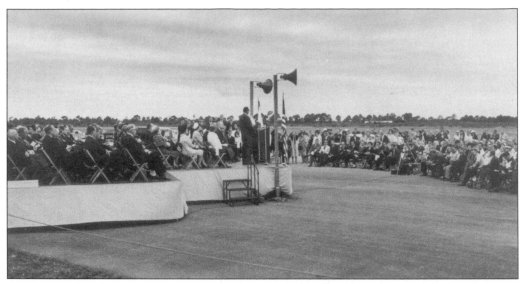

The December 8, 1962 ground-breaking for FAU's new Boca Raton campus took place on an overcast and dismal day. While Governor Bryant delivered his address it drizzled, though it never actually rained. When the Reverend Mother de la Croix, president of Marymount College, spoke, she said she had ended the threat of rain with prayer.

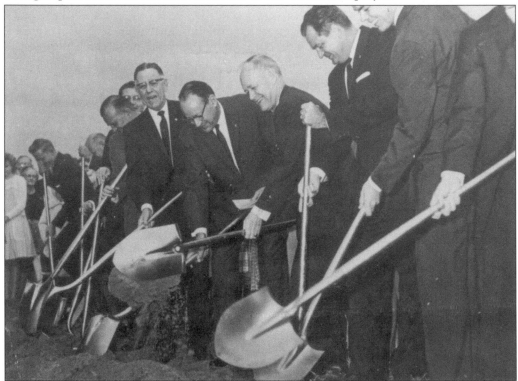

Governor Bryant (third from right) pledged his complete support for the new university during his 1960 election campaign. Here he joins President Williams (to his left), Thomas Fleming (to his right), and members of the board of control for the ground-breaking ceremony. A crowd of almost 2,000 people attended the event.

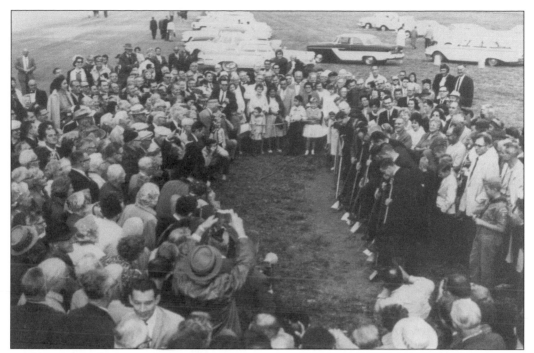

Wielding shovels at the ground-breaking ceremony for FAU's first buildings were state education secretary Thomas D. Bailey, board of control executive director J. Broward Culpepper, and the presidents of the freshmen classes of the area junior colleges who represented the first students to attend the upper-division school when it opened in September 1964.

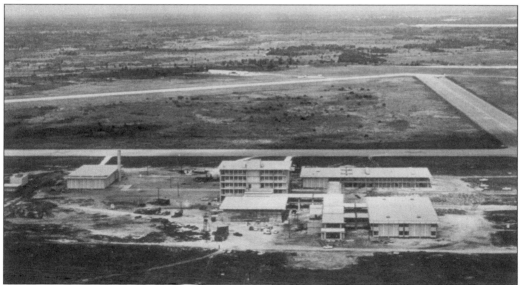

Although the Cuban Missile Crisis prompted fear in the fall of 1962 that the Air Force might reactivate the base, plans continued for the building of the campus. In December 1962, the Edward M. Fleming Construction Company, which submitted the low bid of $4,480,000, received the contract for the campus buildings and by January 1964 construction of the new campus neared completion.

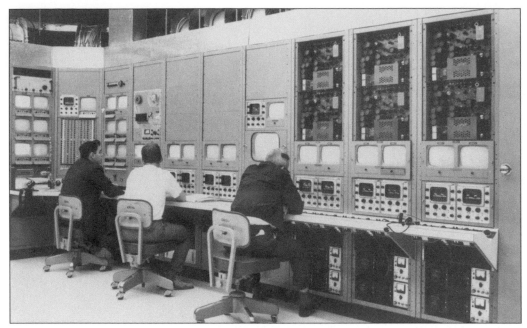

A planning committee, headed by respected educator A.J. Brumbaugh, consulted scholars from many fields before making its report in June 1961. The "Brumbaugh Report" called for an upper-division university with a program that "dovetailed" with those of the state's junior colleges. The report also envisioned a "forward looking" university with a curriculum enriched by the extensive use of modern media aids.

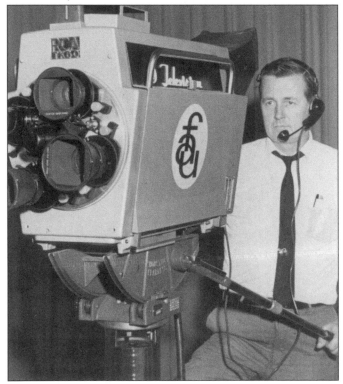

As planning proceeded in Boca Raton, the new media teaching aids became as important as the library. Both the media facilities and the library were placed under the director of learning resources, who was in charge of planning for the two television channels.

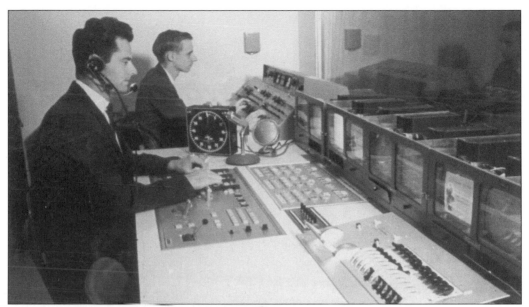

The purpose of FAU's new electronic teaching devices, according to Palmer Pilcher, dean of academic affairs, was "to bring more of man's knowledge to more students on a more effective and ultimately more economic basis."

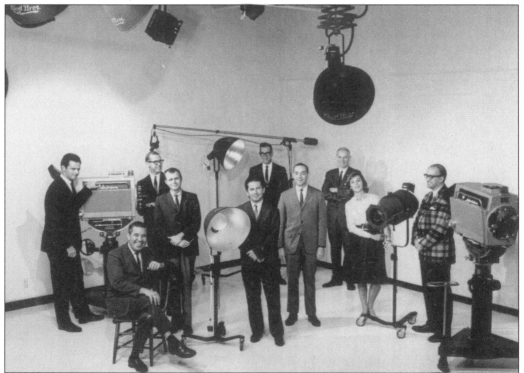

A large staff of radio and television producers and directors were prepared to further the new technical goals of the institution. Shown here, from left to right, are as follows: (front row) Jim Petersen; (seated) Bob Wanless, Dick Brown, Dick Siefert, Rosemarie Studer, and Joe Ceros; (back row) Tom Ryan, Nick Carter, Bill Archer, and Austin Hahn.

Early completion of the Learning Resources Building allowed its large staff to begin work on the technical aspects of the media goals. The building contained a number of large television studios as well as the control rooms and the offices needed to produce numerous teaching programs.

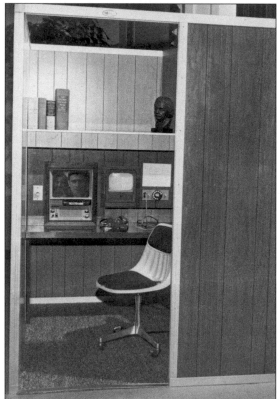

The mock-up of the individual student study center, completed by learning resources personnel in February 1964, "incorporated the latest in electronic wizardry," which included ten-closed-circuit* channels, earphones, and 150 audio channels, some connected to automated teaching machines. The designers allowed space to add newly invented devices.

FAU's early commitment to innovative teaching methods saw Prudence Vaughan hired a year before classes started to catalog art slides, film strips, and other non-book material for the library.

Although the FAU library planned to eliminate the card catalog, substituting a revolutionary computer-generated-bound-book catalog that could be distributed to the many offices and dorms across the campus, when the date for the library's opening approached it still lacked bookcases, making browsing a serious affair.

When FAU opened, most lecture classes were held in the pie-shaped rooms of the Learning Laboratory Building, later called the General Classroom Building South, or "GCS." The open breeze ways and balconies provided pleasant places to wait for a class to begin or to hold a professor-student conference.

One of the large GCS classrooms designed to allow closed-circuit television lectures. This room also had a computerized response system that permitted almost instantaneous response and grading of quizzes. A central control room projected slides and movies into four different classrooms.

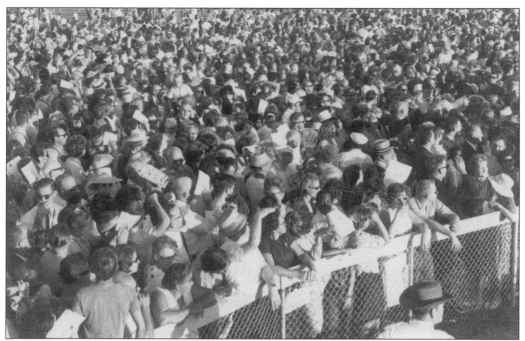

More than 15,000 people heard President Lyndon B. Johnson issue a clarion call for the support of public higher education at the October 1964 dedication ceremony of Florida Atlantic University. Calling for a "new revolution in education" to open the doors of colleges and universities for all who could qualify, the President concluded that he knew no limits to what a fully educated American public could do to enrich life in the next fifty years.

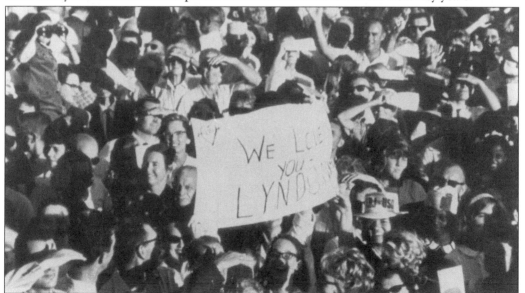

Although elaborate security measures involving Secret Service agents and some 150 area police protected President Johnson, and FAU's dean of academic affairs called for "dignity" during the visit (apparently because demonstrators for Republican candidate Barry Goldwater protested vice presidential candidate Hubert Humphrey's earlier visit to Boca Raton), the crowd seemed extremely supportive of the president.

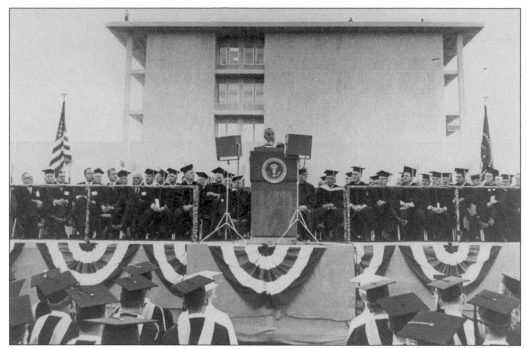

President Johnson spoke at FAU's dedication in October 1964. Thomas Fleming's college friends and early supporters of the university, Senator George Smathers and Congressman Paul Rogers can be seen in the front row to the left of the podium, as can Congressman Claude Pepper. Thomas Fleming, the president's Florida campaign chairman, secured President Johnson's presence at the dedication.

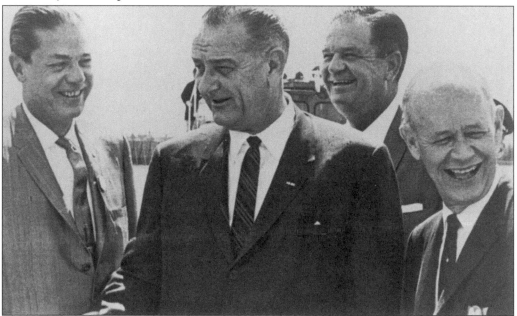

In a light moment during the dedication ceremony, President Johnson is surrounded by loyal supporters. Shown here, from left to right, are Democratic gubernatorial candidate Haydon Burns, President Johnson, Thomas Fleming, and Governor Bryant.

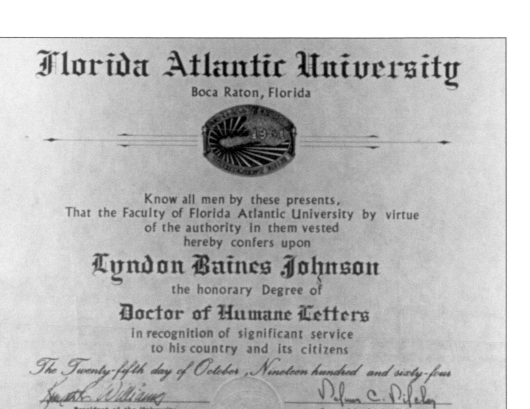

Florida Atlantic University

Boca Raton, Florida

Know all men by these presents,
That the Faculty of Florida Atlantic University by virtue
of the authority in them vested
hereby confers upon

Lyndon Baines Johnson

the honorary Degree of

Doctor of Humane Letters

in recognition of significant service
to his country and its citizens

The Twenty-fifth day of October, Nineteen hundred and sixty-four

President of the University

Dean of Academic Affairs

President Johnson received FAU's first honorary degree during the dedication ceremonies. Hank Schubert, head of the graphics department, hand lettered this first university diploma.

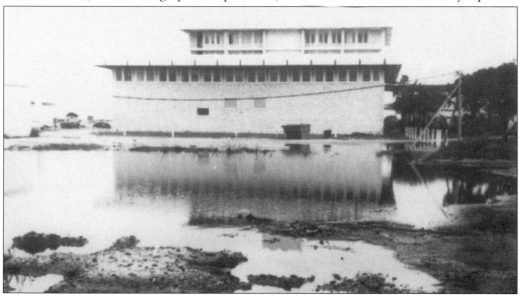

All early estimates had called for 2,000 students to enroll before the opening of the new university. With less than 1,000 actually enrolled in early September, some members of the administration believed that Hurricane Cleo was a blessing in disguise.

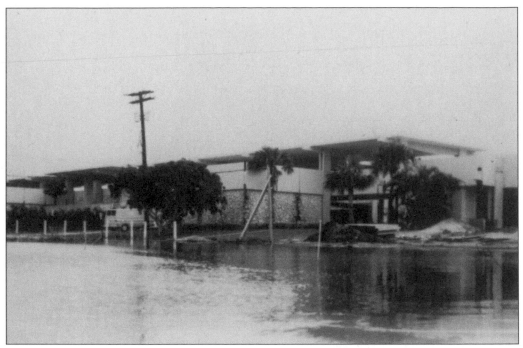

Classes scheduled to begin September 8, 1964 were postponed until September 14 because of campus flooding produced by the hurricane. The flooding shutdown the air-conditioning system and made it impossible to operate the computers needed for registration.

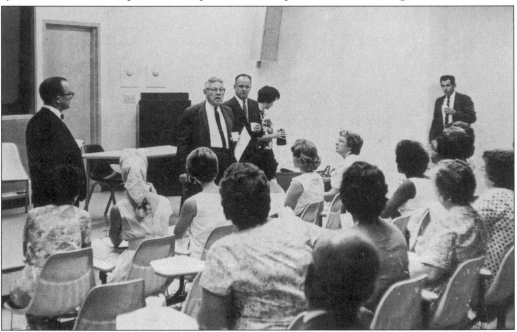

Many different groups visited the new campus in the early days. Seen here entertaining visitors, standing from left to right, are education professor Stephen H. Voss, education dean Ballard Simmons, humanities dean Benjamin Rogers, and continuing education dean Rodney Lane.

President Williams greets Merrill A. Symonds (left), president of Florida Keys Junior College, at a conference held on the new Boca Raton campus aimed at increasing the effectiveness of communications between the junior colleges and the new upper-division state university.

A panel of FAU administrators and faculty explained the goals of the new university during the August 1964 campus meeting of the southern district of the Florida Press Association. Shown, from left to right, are the following: Joel E. Ross, chair of business administration; G. Ballard Simmons, dean of education; unknown; Benjamin F. Rogers, dean of humanities; Stanley W. Wimberly, dean of social science; Palmer C. Pilcher, dean of academic affairs; and Edward Heiliger, director of the library.

Governor-elect Haydon Burns is pictured at a reception before the ceremonies to inaugurate President Williams at Bibletown Auditorium in Boca Raton. In its first years, FAU was forced to use Bibletown and other area churches for its indoor ceremonies as it had no large auditorium of its own.

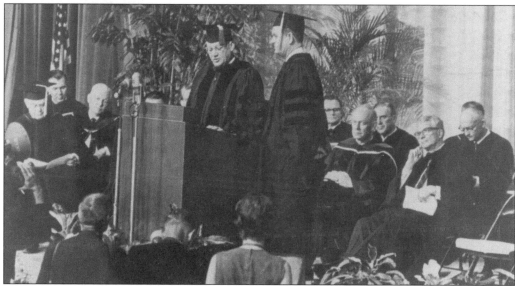

Kenneth Rast Williams was formally inaugurated as FAU's first president on November 12, 1964. Williams, standing at the podium, presented the university's first Distinguished Service Award to Thomas F. Fleming Jr. (on Williams' right), for his efforts in founding the new institution. Governor Farris Bryant, seated to the right of Fleming, received an honorary doctor of law degree.

Shown holding FAU's first Distinguished Service Award following the Inaugural ceremony, from left to right, are Governor Bryant, President Williams, and Thomas Fleming, chair of the FAU Endowment Corporation, who received the award.

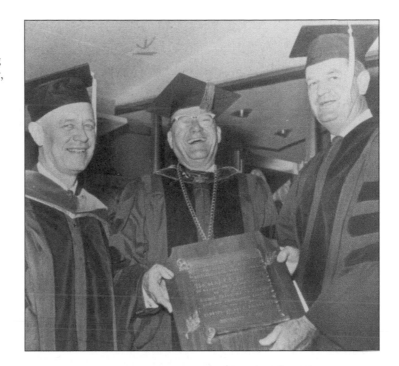

FAU dedicated the two-story science building to Stanton D. Sanson on December 18, 1965. Sanson served as the chair of the education committee of the Council of 100, a Florida leadership group, and had worked to convince state legislators that Florida's financial stability rested on its continued improvement of its educational system.

In September 1964, the campus ground consisted mainly of concrete runways, sand, and sand burrs. In 1967, John Leasor, plant operations draftsman, completes plans for a $20,000 expansion of FAU's irrigation sprinkler system which will add 15 acres of grassy area to the campus.

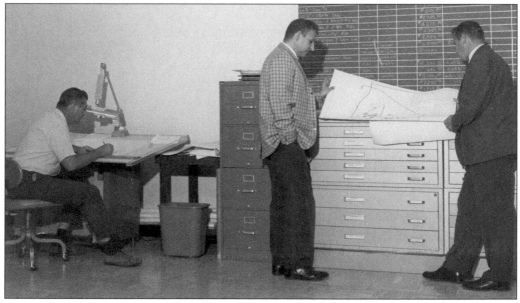

FAU's plant operations division coordinated physical plant expansion and major construction liaison with the board of regent's architect in the university's early years (the board of regents placed the old board of control in 1965). Pictured in this photograph, from left to right, are Ross Snyder (planner), Bob West (assistant director), and Fred Gardner (director).

Two

THE WILLIAMS YEARS
(1966–1973)

Kenneth R. Williams served the university for 11 troubled years. The state of Florida never gave the financial support needed for the innovative program envisioned by the planners. The attempts to implement some of the program with little or no funding often produced poor and unsatisfying results. Students saw little reason to watch professors lecture on television if they lacked the resources to use the media effectively.

By 1967 the original deans of education, business, and humanities had all left their positions. Moreover, Williams had demoted his dean of academic affairs and the director of the library had taken a job in industry. In a major reorganization, Williams appointed Stanley E. Wimberly, dean of social science, to the top academic affairs position (within a few months the title was elevated to vice president). Wimberly, in turn, dismantled many of the new programs, sending the university down a much more traditional road.

The Williams years also saw the rise of student unrest and protest. Opposition to the war in Vietnam, the striving for greater student freedoms, and the relaxation of what had been seen as a set of unchanging moral and social codes, often found the administration opposing the demands of students and appearing out of touch with their world.

The original faculty of the College of Humanities is pictured here on the patio in front of GCS. Shown here are the fine arts department (lower left), the English department (lower right), Dean Benjamin Rogers and the college secretaries (center left), the language department (center right), and the history department (in the rear).

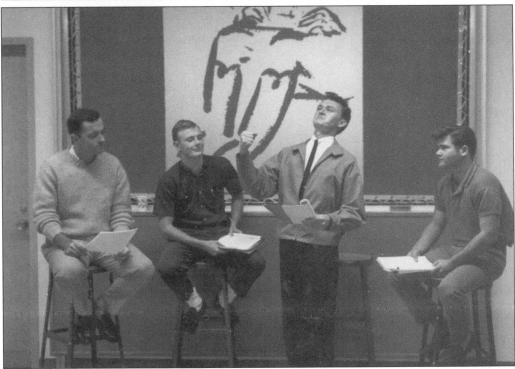

FAU's first theatrical production took place on November 18, 1964, at Marymount College's Founders Hall Auditorium. Professor Joseph Conaway directed a readers' theatre production *Last Letters from Stalingrad*. In the cast, from left to right, are Wayne Rogers, Roger Hofheins, Robert Wilke, and Don Litwin.

In March 1965 FAU awarded a construction contract for $1.36 million to the William A. Berbusse Construction Company for the Humanities Building designed by Clinton Gamble of Fort Lauderdale. At the heart of the new building was the 504-seat theatre designed to serve as a center for teaching, learning, and as an arena for performances in theatre, music, and dance.

P.C. Zanetti of Boca Raton's Engineering Science Division of Scott Aviation Corporation presents a check to Charles R. Stephan, chair of FAU's Department of Ocean Engineering. In the fall of 1965 FAU became the first American university to offer an undergraduate degree in ocean engineering. The program originally required a six-week-summer program of practical laboratory work at sea.

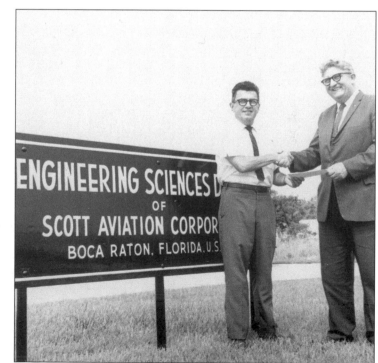

FAU held its first commencement exercises on Saturday afternoon, April 24, 1965, at the First Presbyterian Church. The 29 students who received bachelor degrees heard Clarence B. Hilberry, president of Wayne State University, tell them that the demand for excellence in education "produced your university." He said FAU, with its deep commitment to experimentation in education, had "an enormous responsibility to stimulate all of American education into seeking new and better ways."

FAU's fifth commencement, the first actually held on campus, saw 442 graduates receive degrees on August 13, 1966. Although the ceremony was held on the patio, those who wished could watch the ceremony on closed-circuit television in air-conditioned comfort. William H. Kadel, president of Florida Presbyterian College (today Eckerd College), delivered the commencement address.

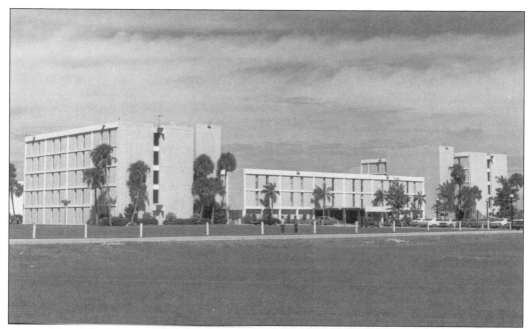

In 1964, FAU had no dormitories. This failure, combined with the extremely inadequate highway system in place at the time, is often cited for the lower-than-expected enrollments of the first-years. Realizing the need for dormitories, the university rushed construction, completing Algonquin and Modoc residential halls in 1965, Mohave and Naskapi in 1967, and Sekoni and Seminole in 1968.

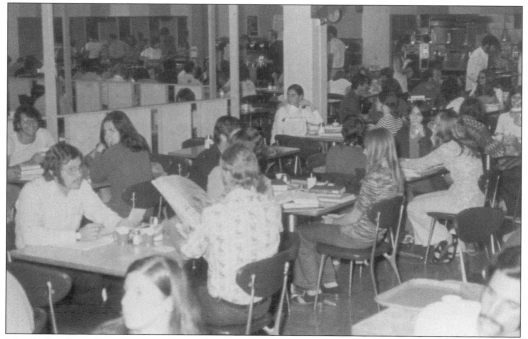

The lack of a cafeteria was often cited as another reason for the low enrollment during the first year. The $900,000 cafeteria opened in November 1965 and proved immediately popular with students, who none-the-less, always complained about the food.

FAU officials began their move into the university's new $1.8 million administration and social science building in early August 1966. Top administrative officers found the procedure "relatively painless" as many had moved five times since the university had entered into its active planning period in 1962.

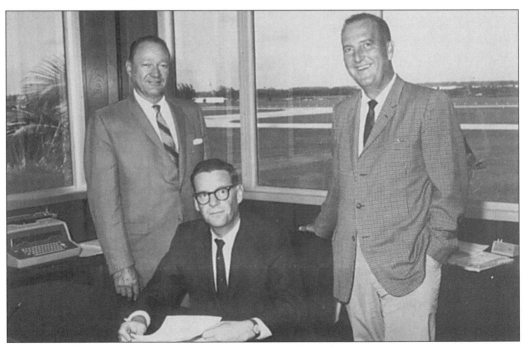

Palmer C. Pilcher (seated), the dean of academic affairs, shows Roger H. Miller (right), dean of administrative affairs, and President Williams (left) his new third-floor office in the recently completed administration building.

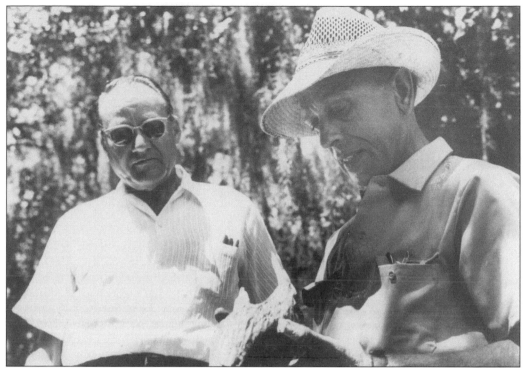

Archaeologist William H. Sears chaired FAU's department of anthropology and directed field school doing work in several areas of the state. Sears, on the right, shows President Williams around the site of Fort Center, a cooperative program with the University of Florida and Colgate University that he directed. Upon his retirement, Sears received an honorary doctor of science degree from the university at the 1983 commencement.

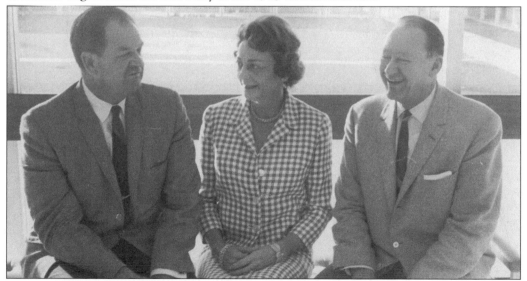

In December 1966 the Board of Directors of the FAU Endowment Corporation met in the new administration building. Shown, from left to right, are Board Chair Thomas Fleming, Lucy Henderson Edmondson, who in 1967 endowed the Alexander D. Henderson University School in honor of her late husband, and President Williams.

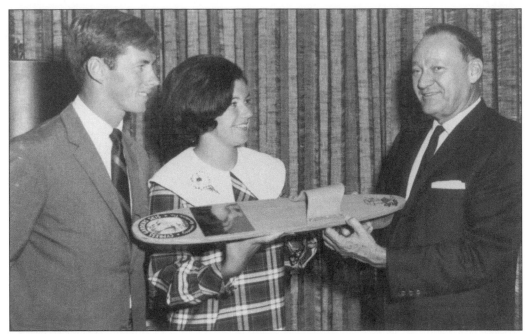

In October 1967, FAU won its first athletic championship when the university's water ski club team placed first in the 21st Southern Annual Water Ski Tournament at Cypress Gardens. Pictured here, from left to right, are team members David Holmes and Lynn Beach as they present President Williams with a ski used during the competition.

At the Fourth Annual Florida Poetry Festival, held at the University of South Florida in 1967, FAU's production of Archibald MacLeish's poem "The Happy Marriage" received a Superior rating in the Readers' Theatre competition. Joseph E. Conaway directed the production. Shown here, from left to right, are Henry Logan, John Campi, Sharon McAllister, Richard Green, Conaway, MacLeish, Lisa Vance, and Susan Kohn.

During a special convocation on April 17, 1967, in the newly completed university theatre, Robert W. Sarnoff, president of the Radio Corporation of America, received the doctor of humane letters degree. In his address, Sarnoff congratulated FAU for its experiments with new technology learning and predicted a new society with all forms of wealth generated through the movement of information.

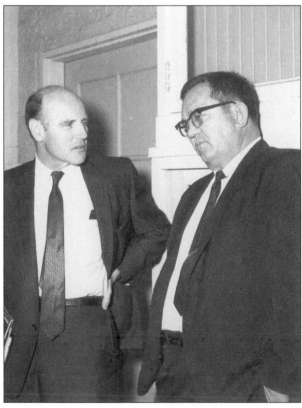

Shown here is university system chancellor Robert B. Mautz (left) with S.E. Wimberly, who was named dean for academic affairs in May 1967. The lack of adequate state funding and lower than anticipated enrollments had caused a rethinking of FAU's commitment to educational experimentation and a major reorganization of the university's administration. Mautz and Wimberly are at Ida Fisher Junior High School in Miami Beach where FAU provided classes for Dade County students before the opening of Florida International University in 1972.

41

In March 1967, Edward Heiliger resigned as director of the library to become librarian for United Aircraft Corporation. With his departure the traditional card catalog replaced his experimental computer-generated-bound-book catalog.

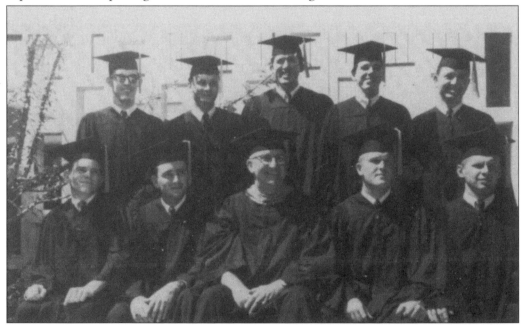

The first class in ocean engineering graduated on April 23, 1967. Pictured here, from left to right, are the following: (front row) Dee Pendley III, Emil Kent Williams, Professor Charles R. Stephan, John Thomas Dade, and Barry Bates; (back row) Martin K. Knapp, Richard C. Asher, Louis S. Brown Jr., Rikki Wells, and William Daly.

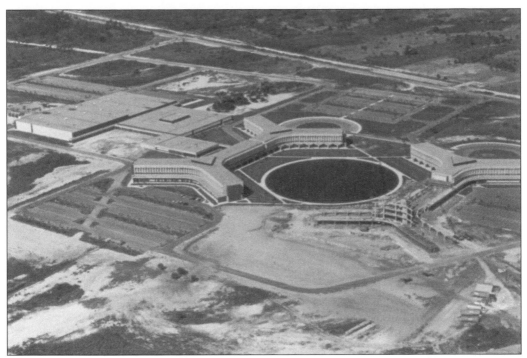

Just as FAU abandoned its attempt to build a brave new educational program based on electronic technology, IBM began building its Boca Raton plant where it developed the personal computer. The IBM PC sparked a revolution in American life, and ironically, could have allowed FAU to institute its early innovative programs.

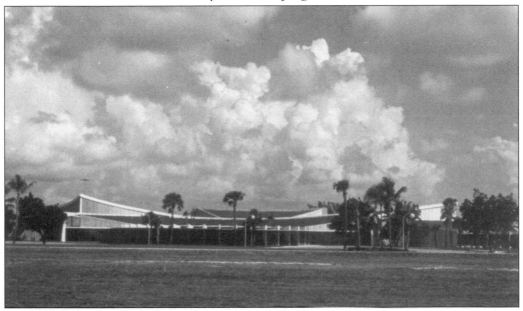

The Alexander D. Henderson University School opened on 23 acres of campus land just north of the 20th Street entrance in September 1968. The new building had 14-pie-shaped classrooms with soundproof walls, and carpeted floors. Television cameras in each classroom allowed taping of both student and teacher "performances."

Shown here is the receiving line at the president's reception for faculty and staff held on November 25, 1968. Shown, from left to right, are (facing the camera) President Williams, Mrs. Williams, and S.E. Wimberly. Shaking hands with Mrs. Williams is French professor Christine Probes.

In 1968, FAU admitted 22 students into a program that allowed bright high school graduates to enroll at the upper-division school and complete their college program in two or three years. Known as faculty scholars, they passed examinations to satisfy basic course requirements. Here Alan Greer (assistant dean) greets three new humanities college faculty scholars at a September 1968 reception.

When Adrienne Falk Levine decided to enroll in the history graduate program at FAU, the Miami resident elected to live in the campus dorms rather than commute the almost 50 miles from her home. "It was a difficult adjustment," but she achieved a "colleague relationship" with her dormitory suite mates. Discussing her thesis, from left to right, are Professor John O'Sullivan, Levine, and Professor Raymond A. Mohl Jr.

Louise Jones became the first Seminole woman to earn a college degree in Florida when she graduated from the College of Business.

In the spring of 1969, before the university built its first gallery, the art department sponsored an outdoor art show and sale in the patio area. Art students and faculty members displayed paintings, prints, and ceramics. The event attracted a large university and town audience.

In the spring of 1969, the board of regents approved intercollegiate athletics for FAU. Many northern schools sent their lacrosse teams to Florida for pre-season practice during spring break. The FAU team played Cornell, Duke, the University of Virginia, and Swartmore College.

Political science professor Douglas Gatlin (standing with coat and tie) is shown talking to new faculty scholars at a welcoming reception. Gatlin became FAU's first distinguished teacher at its initial honors convocation on September 30, 1969.

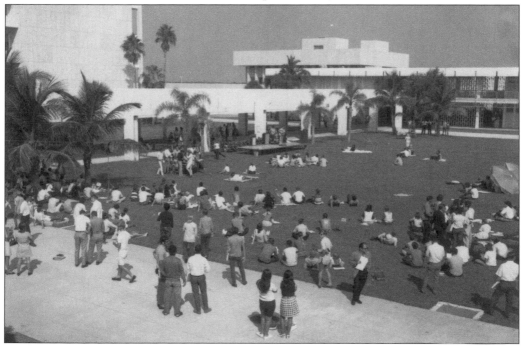

War Moratorium Day, on October 15, 1969, featured faculty speakers who emphasized that protest did not mean disloyalty. Although President Williams refused to suspend classes for the "Day of Awareness," he did encourage members of the university's community to participate "as their conscience dictated."

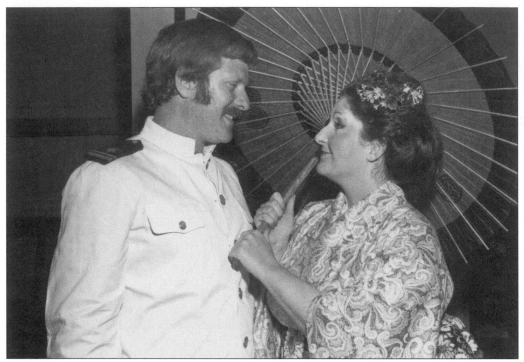

The music department's Richard Wright directed Puccini's *Madame Butterfly* in January 1970 with Anthony Serreo as Lieutenant Pinkerton and Anne Lerner as Cio-Cio San.

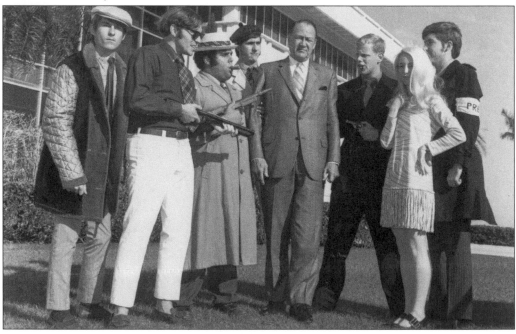

In February 1970, "flapper-era-gangsters" of the Lambda Chi Alpha fraternity, as part of their fund-raising project for scholarships, kidnaped President Williams. Members of the fraternity planned to hold university and city leaders captive for $25, the "ransom" was used for scholarship money for Boca Raton students attending FAU.

48

President Williams dedicated the Theodore Pratt Room of the library on April 26, 1970. Pratt, the author of 35 books including a southeast Florida trilogy, died in December 1969. He gave FAU his collection of first edition books, original manuscripts, and his research notes. The new room, furnished with pieces from Pratt's workroom, served serious creative writers as an office.

Burrowing Owls first came to the FAU campus during the war. They need a semi-tropical wide-open space with flat ground and low ground-level vegetation to survive, and the soil around the runways proved a perfect home. FAU became an official owl sanctuary on April 23, 1971, when as many as 150 owls could be found on campus. Later, the owl became the FAU mascot. At the time, it was said that Roger Miller, "watches over the owls like a mother hen."

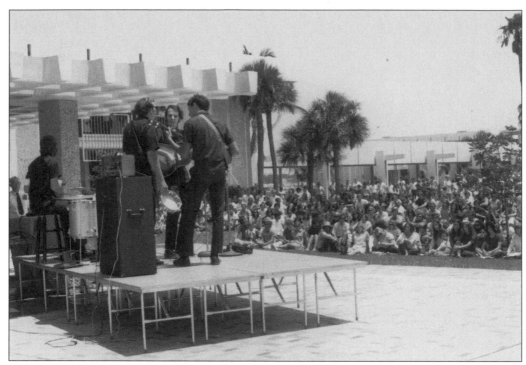

Over 300 students, faculty, and staff gathered for a memorial service for four slain Kent State University students on the afternoon of May 7, 1970. After a week of wrangling with officials over lowering flags to half-mast and canceling classes, President Williams set aside an hour for the service. Three young seminarians from St. Vincent DePaul Catholic Seminary opened the service with the Beatle's song, "Let It Be."

The blue and white FAU flag waved at half-staff as a reminder of the slayings of students Donna Fink and Marlene Mahnke. The students, killed by a roving gang of teenagers for their automobile after leaving an evening class in the T-6 building, were memorialized at a campus service on May 19, 1970.

Without freshmen and sophomore classes, faculty members in the sciences feared they would loose talented science students to Florida's four-year universities. The faculty scholars program, chaired by physics professor Robert E. Stetson, was designed to overcome that problem. Seen here are five students entering the program in the fall of 1970.

Among the campus leaders for the 1970–71 school year were eight student government association senators. Shown here, from left to right, are as follows: (seated) Sandi Justice, Mary Ann Blasco, and Susan Cook; (standing) Tom Weisbaugh, Tom Morin, Bob Johnson, Dave Geneuive, and Jim Black.

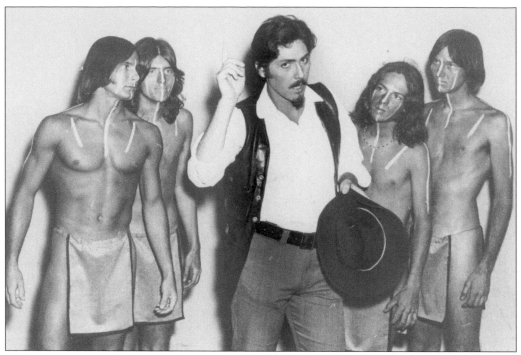

Arthur Kopit's *Indians,* which one critic called a "rip-roaring funny tragic wild west show," opened at the FAU theatre on November 13, 1970 for a two weekend run. Shown here, from left to right, are Jeff Fox, Craig Cherry, Bill Noone as Buffalo Bill Cody, Kerry Gonzolez, and Harry Rotz.

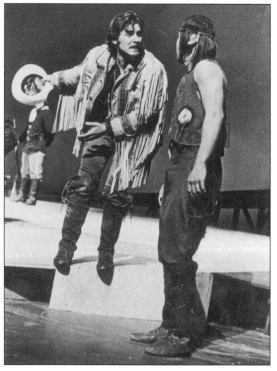

FAU's *Indians* was the only Florida college production selected to compete in the southeastern regional division of the American College Theatre Festival in the Abbeville, South Carolina Opera House on January 14, 1971. Bill Noone as Buffalo Bill, on left, is confronted by Robert Vandenberg as Sitting Bull.

James Mahoney (center) and Robert Rowe (right) received the university's first bachelor of applied arts degrees in law enforcement during the June 1971 graduation ceremony. They are congratulated by Charles McCutcheon (left), chief of Boca Raton's police department and a FAU graduate who received his bachelor's degree in political science.

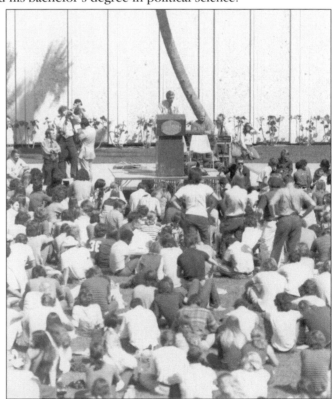

Before Florida's presidential primary in the spring of 1972, FAU received visits from many of the candidates contending for the Democratic party's nomination. John Lindsay, New York City's mayor, speaking to a large crowd, said he felt George Wallace endangered our civil liberties.

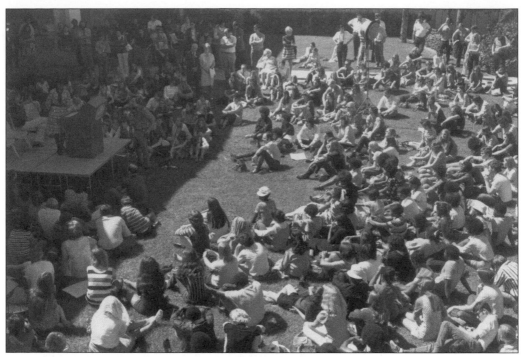

The primary season also brought Shirley Chisholm, a New York congresswoman, who told a large group of students and faculty members "the only thing I have to bring you is my soul and my gut commitment to the American people first of all."

Pulitzer prize winning poet Archibald MacLeish spoke at the annual southeastern poetry festival when it met at FAU in April 1972. Representatives from 23 colleges in Florida and from as far away as Texas, heard the 80-year-old former Librarian of Congress lecture and read from his poetry.

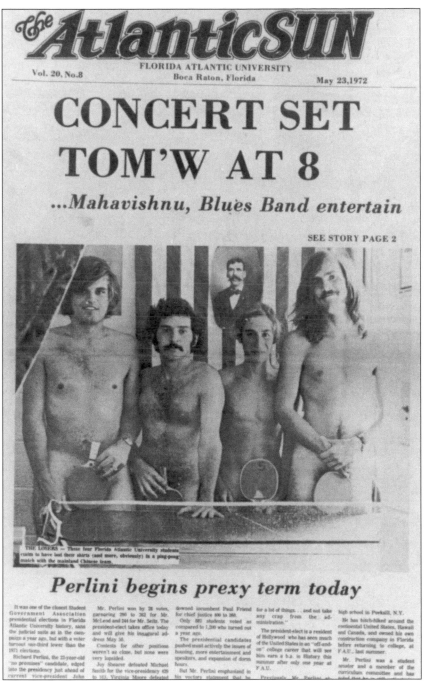

During 1972 the nation saw protests against the war and against authority in general. *Atlantic Sun* editor Ed Schiff challenged the authority of the FAU administration with this front page. He claimed the four students had "lost their shirts (and more, obviously) in a ping-pong match with the mainland Chinese team." President Williams's suspension of the newspaper opened a statewide debate on who controlled the state universities' newspapers. Pictured here, from left to right, are Bill Kiele, Henry Cheili, Phil Materio, and Steven Beamsderfler.

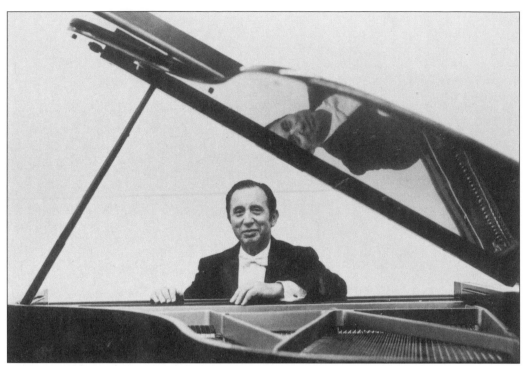

Classical pianist and FAU professor of music Raul Spivak began playing the piano at age five in his home in Buenos Aires. Considered one of Latin America's most prominent musicians, he gave a number of south Florida concerts in 1972 including one at FAU in November.

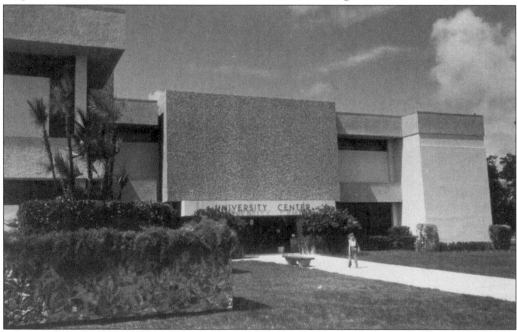

The student center building was dedicated on October 4, 1972. The new facility contained offices and meeting rooms for the student government, organizations, a bookstore, and rathskeller.

Steve Kika, TV graphics manager since 1966, painted the walls of the stairwell at FAU's student center building in 1972. In 1980, Kika earned a bachelor's degree in education and in 1987, a master's degree.

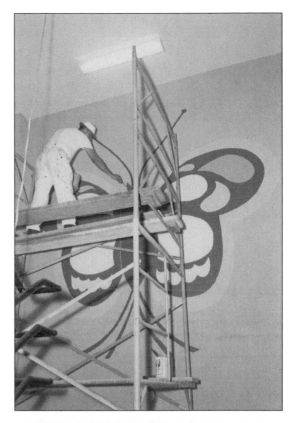

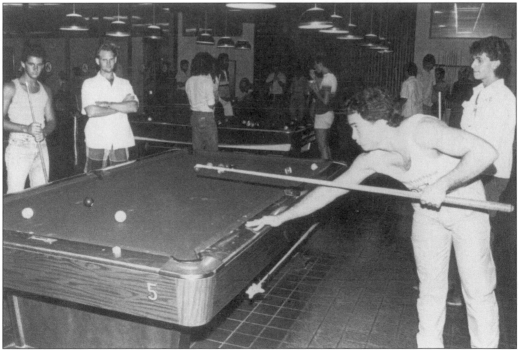

The pool room in the student center building proved popular with many FAU students.

In July 1972, President Williams announced he planned to retire. When the FAU graduation committee asked Williams to speak at what would be his last commencement in April 1973, students protested and called for a minority speaker. Williams then graciously stepped aside, inviting Georgia state representative Julian Bond to give the graduation address.

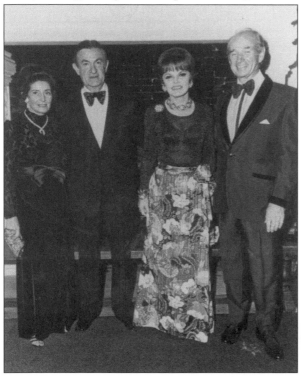

A surprise announcement at the December 1972 recognition dinner attended by 350 guests at the Boca Raton Hotel and Club revealed a $50,000 endowment fund established in President Williams's name. Among the donors, from left to right, are Dorothy F. Schmidt, Dr. and Mrs. Samuel Turcek, and Charles Schmidt. The Schmidt family became the university's major benefactor with many additional gifts over the next quarter century.

Three

THE CREECH YEARS (1973–1983)

In 1973, the Florida Board of Regents named Glenwood Creech FAU's second president. Creech, a graduate of the University of Kentucky's agricultural program, earned his doctorate at the University of Wisconsin-Madison in 1957. At the time of his appointment he served as vice president for university relations at Kentucky and many believed FAU needed a president skilled in the field of public relations. Nonetheless, his selection caused controversy as the university's 17-member selection committee of students, faculty, administrators, and alumni, had not included him on its list of six candidates recommended to the board of regents.

As president, Creech had great success as a fund-raiser. The Florida legislature initiated a matching program where the state added $400,000 to every $600,000 raised to fund eminent scholar chairs. Under Creech the university received the Charles E. Schmidt chair in engineering, the Dorothy F. Schmidt chair in performing and visual arts, the Charles Steward Mott chair in community education, the Eugene and Christine Lynn chair in business, the Robert J. Morrow chair in social science, and on his retirement, friends founded the Glenwood and Martha Creech chair in science.

Creech's presidency also had to contend with lower than expected enrollments and less than adequate budgets. He also had to fight to keep the legislature from merging FAU with Florida International in Miami or the University of Florida. It was also under Creech that the university made the commitment to provide more classes and degree programs in Broward County.

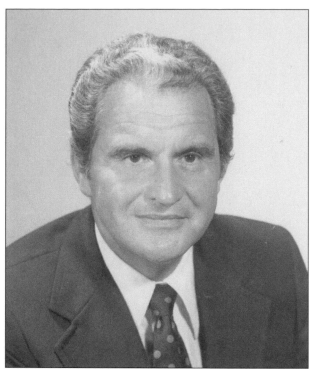

In 1973 the board of regents named Glenwood L. Creech, vice president for university relations at the University of Kentucky, as Florida Atlantic University's second president.

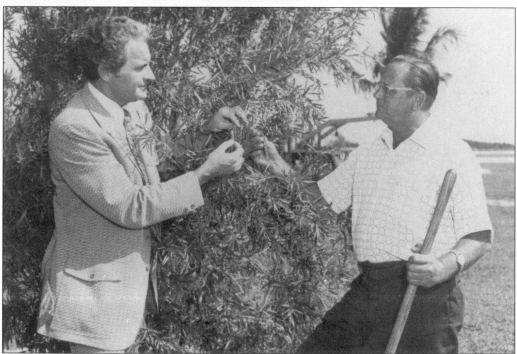

New FAU president Glenwood L. Creech (left) receives a horticultural lesson from campus grounds supervisor John E. Williams. Creech, a native of Kentucky, learned about bottlebrush, cocos plumosa, acacia, jacaranda, and that there are hundreds of different types of palms.

David Kummer (right), a 123-pound 18-year-old faculty scholar, lifted more than 200 pounds to become a record-breaking champion at the National Collegiate Weight-lifting Championship held in White Water, Wisconsin. He was sponsored by the FAU Weight-lifting Club advised by political science professor Michael Giles.

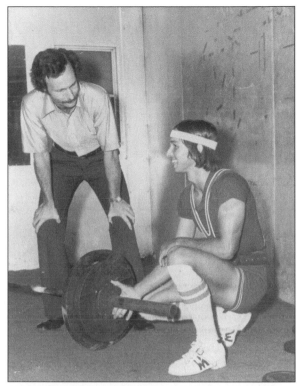

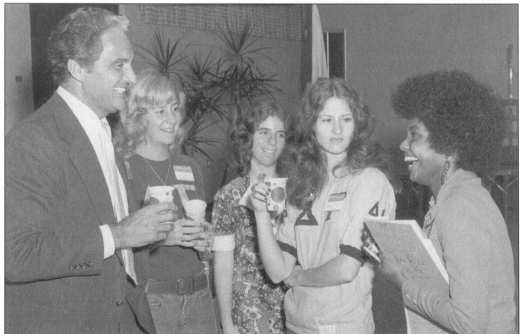

President Creech came to FAU in 1973 from the University of Kentucky. He said he accepted the FAU post partially because the school was "not hidebound with tradition." At FAU he planned to make learning "an exciting thing for students." Here he is seen at a new students' reception in the fall of 1973.

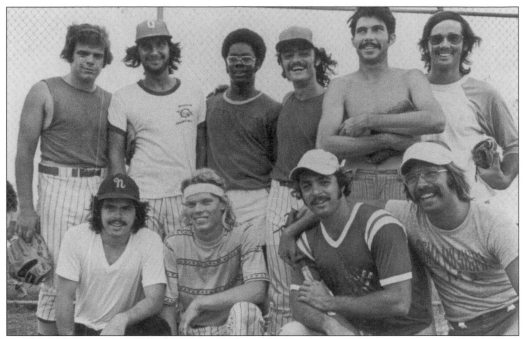

Members of the Superfly intramural softball team posed for their portrait in 1973. Shown here, from left to right, are the following: (front row) Mike Risco, Moses Kirkconnell, John Petito, and Gary Lobel; (back row) Rik Dytrych, Frank Yamello, Wallace Key, Ray Ciardiello, Luis Cabrera, and Mick Steffan.

Phi Beta Lambda, the national collegiate fraternity for business administration and business education students awarded Laura D. Gockel first place as Miss Future Business Teacher at its 1973 leadership conference in Washington, D.C. Representatives from 22 colleges and universities participated in the contest.

On November 8, 1973 the Alumni Association held a family barbecue at its annual meeting and election of directors. Among the guests were former Governor Leroy Collins (third from left) and on his left, Myrtle Butts Fleming.

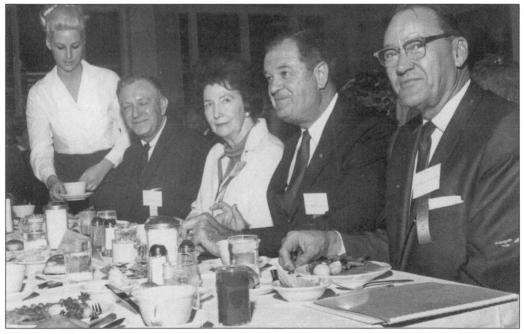

Although Glenwood Creech had become FAU president on July 1, 1973, Kenneth Williams returned to attend the Alumni Association family barbecue. Beginning second from left are Mrs. Williams, Thomas Fleming, and Kenneth Williams.

Lee Harris, a senior in engineering, received FAU's most significant scholastic award, the $1,000 S.E. Wimberly Scholarship. Harris is seen here with President Creech (left) after the Honors Convocation on October 8, 1973.

FAU men's varsity tennis played a heavy schedule under coach Bob Swanson in the early 1970s. Their matches included some of the leading teams of the southeast such as the University of Florida, Georgia Tech, the University of South Florida, and Rollins. Pictured here is the 1973 men's tennis team.

In November 1973, art professor David Tell opened an exhibit of 100 of his "Raku" pottery pieces in the gallery of the university library. "Raku" is black and white pottery with a distinctive cracked appearance made by an ancient Korean method of rapidly cooling fired pottery stuffed with straw or leaves and placed inside a closed container.

In 1973 the Garden Club of America presented its Founders Fund Award to the Pine Jog Environmental Science Center. Accepting the award from representatives of the Garden Club is Elizabeth Donnell Kay (left), who donated Pine Jog to FAU.

Retired Pennsylvania State University drama professor Robert Reifsneider became a visiting professor of dance and body movement at FAU in 1974. In February he served as choreographer of the long running off-Broadway show *The Fantasticks*. Reifsneider (left) works with the Indian, played by student Joe Dyson, while Joseph Conaway, the show's director and Reifsneider's former student, looks on.

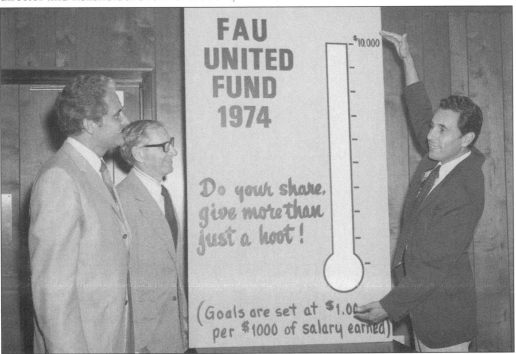

In 1974 the university community's goal for the United Fund was set at $10,000. President Creech (left) named the director of libraries Peter Speyers-Duran (right) as the chairman of the 1974 campaign. Connor Tjarks, assistant director of the library, is on Creech's left.

Professor Ian Brown, department of physics, was awarded a $13,000 grant in March 1974 to experiment with a heating process leading to the production of fusion energy. Brown called fusion energy an "untapped source...that could power the world for millions of years."

Shown hanging the Florida Artist Group Show in the humanities-library art gallery are, from left to right, art professor Robert Watson and art major Robi Pollard. The juried show was held in connection with the Florida League of Arts delegate assembly meeting at FAU.

In the autumn of 1975, dormitory residents went all out in welcoming new students.

Over the years of his presidency, Glenwood Creech traditionally held a picnic for new students at the university center. Here students of the Class of 1977 enjoy fried chicken while sitting around the "fountain."

Other students, including President Creech, ate their picnic lunch on the grass outside the building.

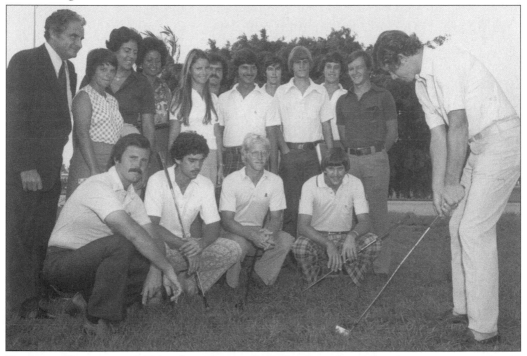

Varsity golf came to FAU in the winter of 1972 when the university team came in 17 out of 17 in the Florida Inter-Collegiate Tournament. Here President Creech poses with the 1976 team.

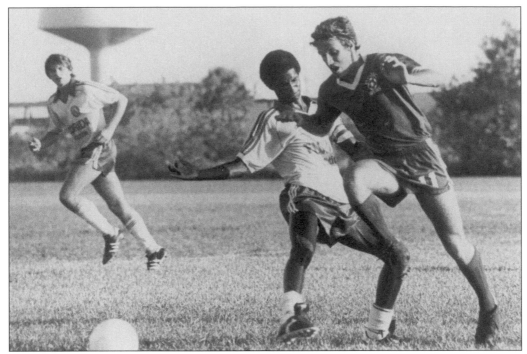

The men's soccer team coached by Jeff Knott in a hard fought game of the mid-1970s. Varsity soccer came to FAU in 1970 under captain Rich McClellan. That first disappointing season saw losses to the Universities of Miami and Florida.

Fleming Hall was dedicated on October 31, 1977, to the memory of Thomas F. Fleming Jr. who had died the previous year. Fleming had worked throughout the later years of his life for the cause of higher education in Florida. As a chairman of the state chamber of commerce group called "Citizens for Florida's Future," he spearheaded approval of a constitutional amendment to allow a $75 million bond issue for higher education.

In celebration of America's bicentennial, the Exchange Club of Boca Raton gave FAU a collection of laminated documents important in American history. Shown here, from left to right, are J. Patrick Lynch, chair of the freedom shrine committee of the club; Kenneth Michels, who had replaced S. E. Wimberly as vice president for academic affairs in 1971; Peter Spyers-Duran, director of the library; and Gary Hickory, president of the local club.

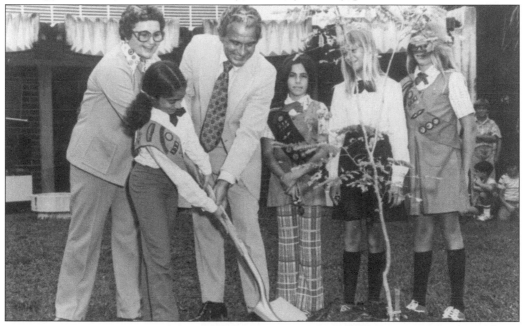

President Creech participates in the planting of a royal poinciana tree at the Henderson University School. The tree was the gift of the girl scout troop that also took part in the ceremony.

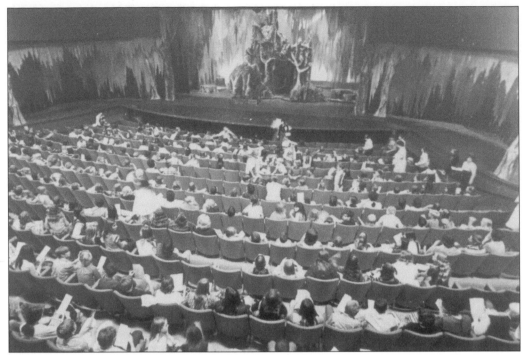

The FAU theatre and stage, just before a 1977 performance of Shakespeare's *Love's Labour's Lost* directed by Joseph Conaway.

The 1977 scholarship convocation saw English professor Howard Pearce named Distinguished Teacher of the year. Pictured, left to right, are vice president Kenneth Michels, Pearce, and President Creech.

Humanities college jocks in the late 1970s support intramural participation. Shown here, from left to right, are philosophy professor Thomas Baxley and Dean Jack Suberman, who both played basketball at the University of Florida; history professor William F. Marina, who played football at the University of Miami; and theatre professor Sydney James, who was a swimmer.

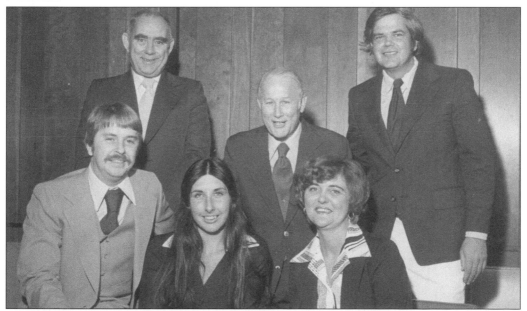

The English Speaking Union's Fort Lauderdale chapter presented $1,330 scholarships for study at English universities in the summer of 1978 to FAU graduate students in English and history. Shown here, from left to right, are the following: (seated) Richard Hersh, Melissa Hirst, and Joanne Connelly; (standing) English chair William T. Coyle (scholarship chair of the English Speaking Union Berkley Schaub) and history chair John O'Sullivan.

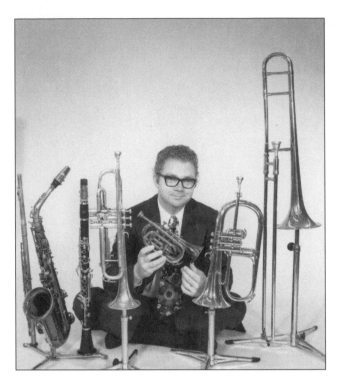

Music professor Bill Prince is shown with some of the instruments on which he performed professionally with such greats as Buddy Rich and Billy Maxted. At FAU he taught jazz and headed the jazz ensemble and band.

Martha and Glenwood Creech (standing) with Johanna Morrow, who presented the FAU Foundation with a bequest from her late husband, physician Robert J. Morrow, to complete the university's Eminent Scholar's Chair in Social Science.

In 1980–81, FAU played its first season of varsity basketball under coach Steven F. Traylor, a graduate of Otterbein College and Ohio State University. During the first season, FAU played 30 games, meeting Columbia and Wesleyan Universities, Bowdoin College, and various Florida institutions including Miami's Florida Memorial College.

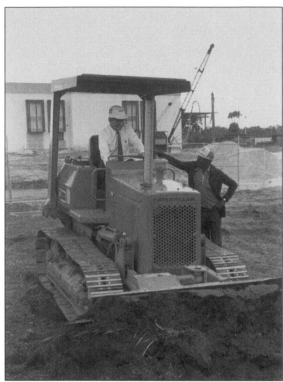

At the November 13, 1980 ground-breaking for the engineering building, a hard-hat wearing and carefully supervised President Creech also broke new ground by lifting the first scoop of earth at the site from atop a bulldozer.

The new engineering building opened in May 1982. The $5 million 57,000-square-foot project with innovative energy saving devices was designed by Smith Architectural Group of Miami to house offices, classrooms, and laboratories for the departments of electrical, mechanical, and ocean engineering.

The FAU auditorium, built as an eastern extension to the university center, opened in the spring of 1982. The $2.3 million facility seated 2,400 people and quickly became the Boca Raton home for the Florida Philharmonic Orchestra and the Boca Raton Pops as well as the venue for numerous university events.

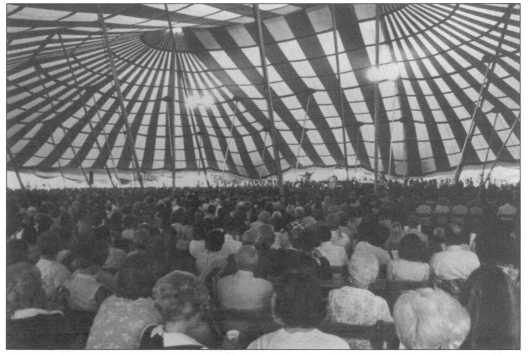

Commencement ceremonies in the "Big Top," whether west of the administration building or north of the university center, became a FAU graduation tradition. This is the May 12, 1982 ceremony when Jean Houston received a honorary degree.

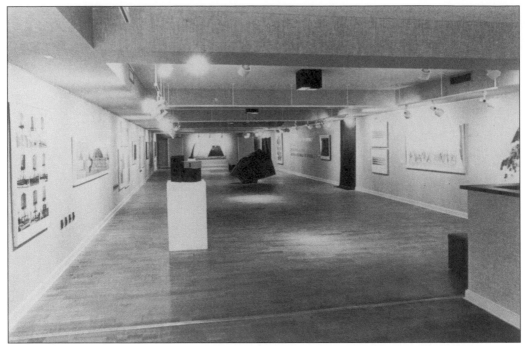

The Lullis and Rolland Ritter Art Gallery opened on the second floor walkway east of the library in the fall of 1982. Myrtle Butts Fleming led the campaign to match the Ritters' $90,000 challenge grant. One of the first exhibits in the new gallery was the collection of Beany Backus's Florida paintings given to FAU by Thomas F. Fleming Jr.

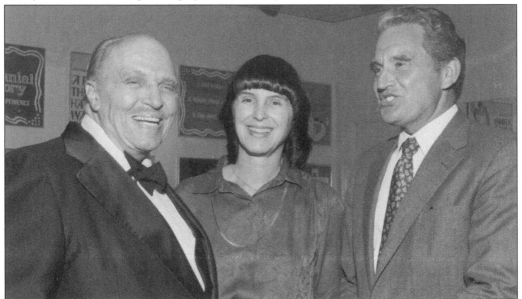

President Creech, seen here with his successor, Helen Popovich (the first woman to hold a university presidency in the state system), and first Dorothy F. Schmidt Eminent Scholar, theatre legend Joshua Logan. Logan held the chair between 1983 and 1986 when ill-health forced him to step down. During this time Logan directed his last show, *Huck and Jim on the Mississippi,* at FAU.

Four

THE POPOVICH YEARS (1983–1990)

Helen Popovich became FAU's third president in August 1983. As the first woman to hold the office of president in the entire state university system, she used the position to work towards the hiring of more women and members of minority groups. She also supported women's studies and saw the Women's Studies Certificate program approved in 1986. Popovich, who graduated from the University of Texas-El Paso in 1955, received her doctorate in English from the University of Kansas in 1965. She taught at the University of South Florida from 1965 to 1978, serving as associate dean of arts and letters the last two years. In 1978 she became dean of liberal arts at Winona State University in Minnesota; in 1980 she was promoted to vice president of academic affairs; and eventually served as acting president for 18 months before coming to FAU. The FAU faculty seemed genuinely pleased with the appointment with sentiment favoring her Florida experience and outstanding qualifications.

Popovich's first year saw Joshua Logan direct his play *Huck and Jim on the Mississippi* as eminent scholar in theatre. By the fall of 1984, with the arrival of a new freshman class, FAU's dependence on graduates of the area community colleges ended. Unfortunately, the early promise of Popovich's administration soon ended and she was hit by a series of problems that ultimately threatened her presidency.

The most serious of these came in an auditor's report issued in October 1986 charging mismanagement and fiscal irregularities. Although the auditor found no evidence of criminal wrong doing, the report suggested a lack of leadership and supervision. In the end, Popovich demoted the vice presidents for academic affairs and administrative affairs, and transferred the director of purchasing. While Chancellor Charles Reed said he supported Popovich, and a regent claimed that she had inherited others' problems, on December 2, 1988, she resigned and in May received appointment as president of Ferris State University in Michigan.

The Florida Board of Regents named Helen Popovich FAU's third president at its July 1983 meeting. Popovich, who taught English and served as an associate dean at the University of South Florida in the 1960s and 1970s, came to FAU from Winona State University in Minnesota where she had been acting president since 1981. The head of the FAU Foundation, George Elmore greets the new president.

Geography professor Ronald Schultz, FAU's 1982–83 Distinguished Teacher, introduces his mother Eleanor (left) to President Popovich (right) while his wife, Darlene (center), looks on.

Governor Bob Graham appointed John DeGrove, former dean of the social science college and director of the FAU-FIU Joint Center for Environmental and Urban Problems, head of the state department of community affairs in May 1983. In his new position, DeGrove had a budget of $75.9 million to administer and control over Florida's environmental and growth regulations that he had been instrumental in writing.

At the November 1983 meeting, the board of regents approved adding freshmen and sophomore classes at FAU in the fall of 1984. Through the efforts of regent Bill Leonard of Fort Lauderdale, the board also granted $75,000 to help plan the new program.

FAU's teaching gymnasium opened in the spring of 1984 in time for the university's 27th graduation in April. The $5 million, 70,000-square-foot facility included a 5,300-seat arena, teaching lab, gymnastic area, and offices.

With delegates from over 140 colleges and universities from across the United States participating in the academic procession, FAU installed its third president with pomp and ceremony on February 10, 1984. Popovich is wearing the president's medallion.

Attending the 1984 inaugural reception in the new gymnasium, from left to right, are Claudene Pinder, Arthur Evans, Carol Jones, and Anthony Russell.

Student supervisor Mark Miele (left) demonstrated the universal-type equipment to student Dennis Lange in the weights and conditioning room of FAU's new teaching gymnasium.

In the early 1980s, FAU sold its facility on Forty-Fifth Street in West Palm Beach and began the quest for a permanent north county home that would not end for almost two decades with the opening of the Jupiter campus in 1999.

FAU's 1984 baseball team earned a 40-15 record and was #8 in the NCAA national rankings. Pictured, from left to right, are the following: (bottom row) M. Barrella, R. Mattone, M. Welch, S. Lezotte, and L. Cleaver; (middle row) J. Hendry, L. Merino, B. Shiver, J. Thompson, J. Hanrahan, D. Strode, and C. Owens; (top row) B. Tease, D. Gonring, L. Goebbert, M. Ryan, K. Foley, W. Hendricks (assistant coach), P. Murphy (assistant coach), and S. Traylor (head coach).

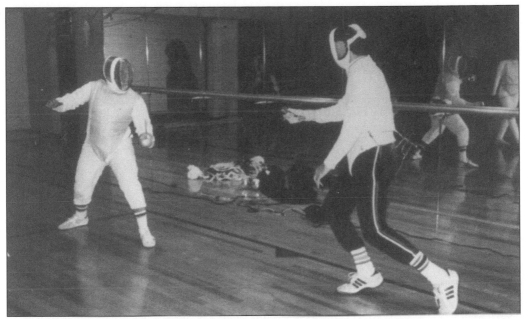

In 1984 the Florida Intercollegiate Fencing Association held its tournament at FAU and team members Neil Chang and Iiro Hinuonen placed in the top three positions with the foil, saber, and epee weapons. The FAU team was coached by Carolyn Parker and Frank Schroeck. Chang, a history major, also received the Kenneth R. Williams Endowment Award at the spring 1984 graduation.

University scholars at the 15th annual honors convocation on September 20, 1984. Shown here, from left to right, are Miguel M. Berthin, Patricia T. Scalise, Kathy H. Yeary, S.E. Wimberly Scholar Carol Grochowiak, Mary A. Schulte, Karl Weiss, Judith C. Wagner, Wendy A. Piper, and Karen S. Kirchler.

Attending the reception following the FAU Foundation annual meeting and election of officers in June 1985, from left to right, are FAU director of alumni affairs Elfriede Lynch, Henry R. Davis (a member of the President's Club), and Alumni Association President John Pritchard.

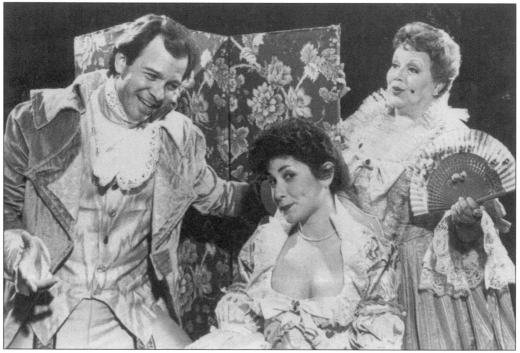

FAU's summer festival theatre repertory in 1985 presented Richard Sheridan's *The Rivals*. Shown here, from left to right, are Jack Hrkach as Captain Absolute, Nancy Ellison as Lydia Languish, and Joy Johnson as Mrs. Malaprop.

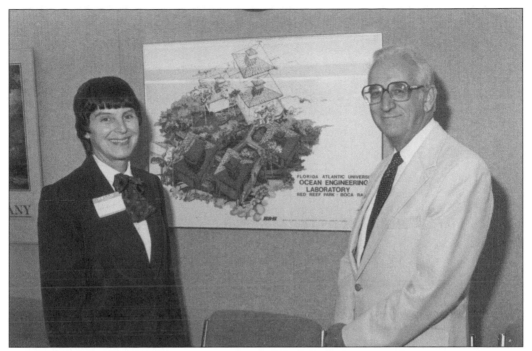

President Popovich with Boca Raton mayor William Konrad pose at the opening reception for the Gumbo Limbo nature center. On the wall is a drawing of the ocean engineering laboratory at Red Reef Park.

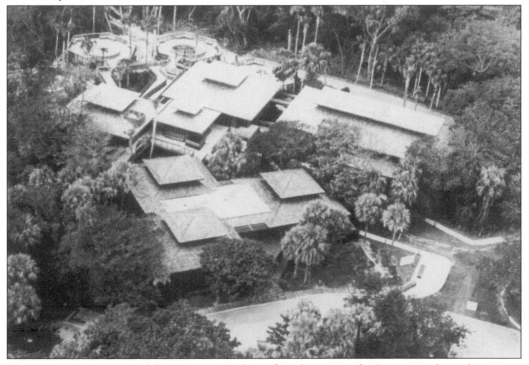

The ocean engineering laboratory at Red Reef Park on North Ocean Boulevard in Boca Raton is seen from the air.

David Lowe of the FAU Foundation joined Elsie Fields, chair of the Sculpture Garden Committee, at a meeting in 1985. Lowe said he hoped the garden could be a tool to "further international harmony."

Daniel A. Mica, the first president of the FAU student body received his bachelor's degree in 1966. He became the first FAU graduate to be elected to the Congress. In 1985, while he was serving his fourth term, the university awarded him an honorary doctorate.

Joshua Logan, the Dorothy F. Schmidt Eminent Scholar from 1983 to 1986, received an honorary doctor of humane letters degree from President Popovich at the April 25, 1986 graduation ceremony. At the same ceremony, FAU awarded an honorary doctor of science degree to Neil Frank, director of the National Hurricane Center in Coral Gables.

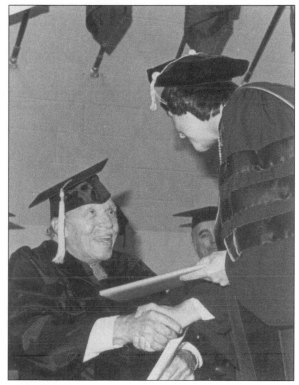

Edward Albee, an internationally renowned playwright and two time Pulitzer prize winner, filled the Dorothy F. Schmidt Eminent Scholar Chair for the autumn semester of 1986. Albee, the author of *Who's Afraid of Virginia Woolf,* gave a seminar entitled "The New Play and its Production" using his own plays as texts.

President Popovich was committed to lead FAU into a new era in affirmative action and with her encouragement more women and minority groups joined the FAU faculty and administration.

Attending a chapter meeting of Pi Sigma Alpha, from left to right, are social science dean Robert Huckshorn, vice president for academic affairs Kenneth Michels, state senator and 1968 FAU graduate Ken Jenne, and President Popovich.

Toni Carbo Bearman, dean of library science at the University of Pittsburgh, spoke at the rededication for the expanded library in June 1987. Edward Heiliger, FAU's first librarian, attended the ceremonies. Spillis, Candela, and Partners of Coral Gables designed the three-story, 86,268-square-foot addition that connected to the older section by a 60-by-80-foot atrium.

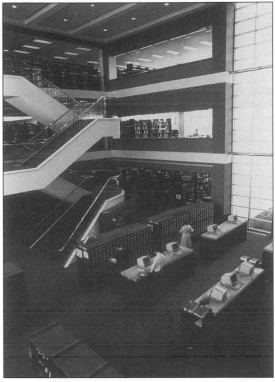

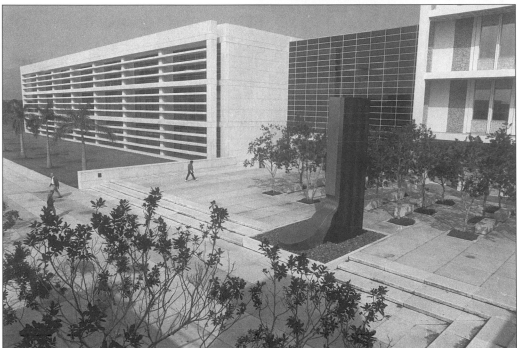

Florida's arts in state buildings program mandates that a small percentage of the cost of all public buildings be designated for art. As part of the new library wing, FAU received Dirck Cruser's stainless steel and weathered steel sculpture, "Collective Memory."

Actor, playwright, director, and producer Hume Cronyn added the Dorothy F. Schmidt Eminent Scholar in Theatre award to his many other titles in 1987–88. Cronyn, who received a Tony award for his role of Polonius in Richard Burton's *Hamlet* in 1964, conducted a master acting class for FAU undergraduate and graduate students. He is seen here, from left to right, with theatre chair Joseph Conaway and arts and humanities dean Sandra Norton.

The FAU Foundation welcomed eminent scholar Hume Cronyn with a festive brunch in the theatre's green room. Shown here, from left to right, are President Popovich, Hume Cronyn, and vice president for university relations, Adelaide R. Snyder.

FAU held its first classes in the sleek $10 million nine-story Reubin Askew Tower in downtown Fort Lauderdale on January 7, 1987. The tower was a major component in the revitalization of the downtown area.

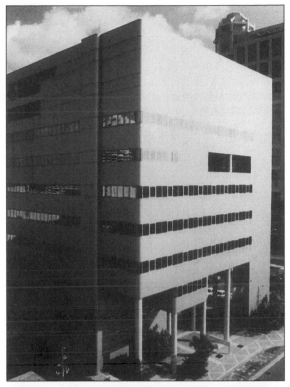

Attending a reception on the humanities building patio, from left to right, are state senator and FAU 1968 graduate Ken Jenne, board of regents member Robert Dressler, and President Popovich.

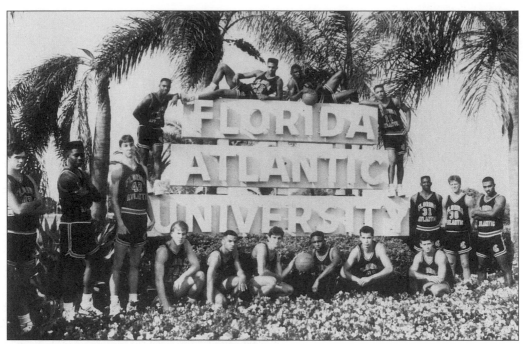

The university's winning 1988–89 basketball team and the Twentieth Street sign.

Stanford M. Lyman, who holds the Robert J. Morrow Eminent Scholar Chair in Social Science, is shown lecturing in the University Center's Gold Coast Room in February 1988. Lyman, who came to FAU in 1985, is an authority on ethnic and racial relations with scholarly interests that range across disciplinary lines from sociology to psychology and include history, literature, and anthropology.

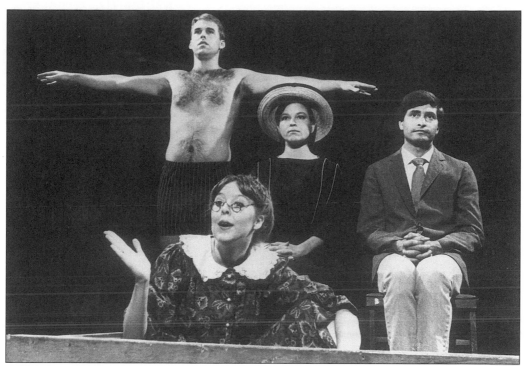

Edward Albee's *The Sandbox*, part of "Pieces 'N Bits," presented by FAU's summer festival theatre repertory in 1989, saw Sally Mullins (front) cast as Grandma, and left to right, Doug Ronk as The Young Man, Tracy Clahan as Mommy, and Lou Solomon as the Musician.

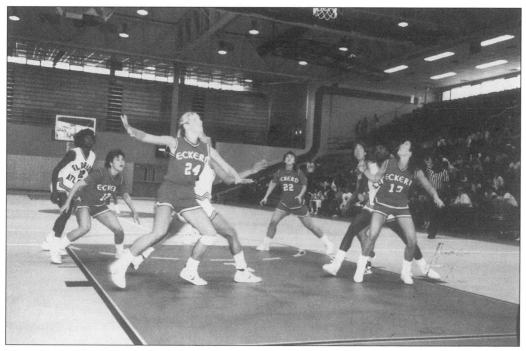

The winning FAU women's basketball team plays Eckerd College.

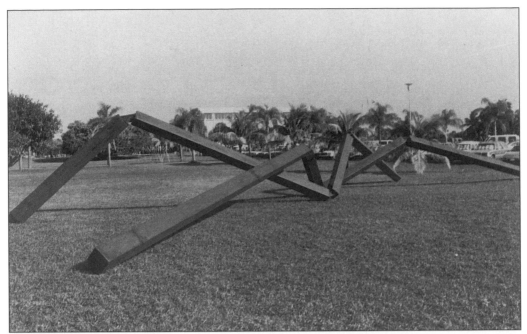

John Henry's 1966 72-foot-long steel sculpture entitled "Reef" was added to the FAU Sculpture Garden through the gift of Maury Lipschultz.

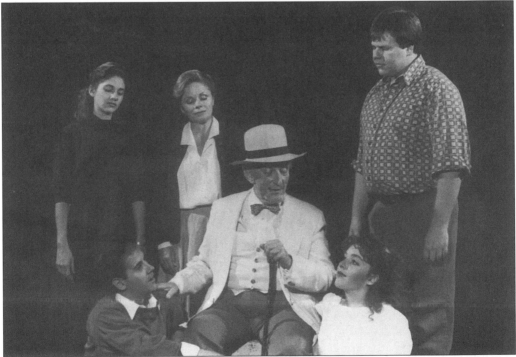

Theatre professor J. Robert Dietz (in hat) played Sorim in Anton Chekhov's comedy *The Seagull*. Shown here, from left to right, are the following: (front) William E. Olson, who had the role of Konstantine, and Angela Snead as Nina; (back row) Julie Tudor, Deborah Sanchez, and Gary Brame.

98

An elementary school class on a field trip to the Pine Jog Environmental Education Center receive first-hand instruction on nature's wonders. The center, resting on 150 acres of natural wilderness, is an unique public/private sector partnership administered by FAU's education college.

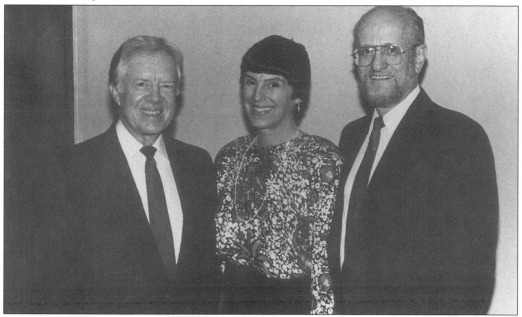

Former president Jimmy Carter spoke at an FAU Foundation fund-raiser in February 1989. Pictured at a pre-speech dinner are, from left to right, President Carter, President Popovich, and Don MacConnell (President Popovich's husband).

Music professor John Hutchcroft conducts a Sunday afternoon FAU orchestra concert in the biological gardens across from the old humanities building.

At a formal holiday reception, from left to right, are President Popovich, Dorothy F. Schmidt, and Myrtle Butts Fleming.

Five

THE CATANESE YEARS
(1990–2000)

The board of regents selected Anthony James Catanese as FAU's fourth president on October 11, 1989. When he arrived in January 1990 he faced a campus in disarray. The former president had been replaced by an interim administrator who had fired the longest serving vice president. Her dismissal had caused a revolt among many of the university's most generous donors. Moreover, Broward state legislators claimed FAU had short-changed that county in providing courses and programs and mounted an effort to create a new state university in Broward.

Where earlier presidents had seen FAU as a Boca Raton institution with satellite centers, Catanese decided to create a truly regional university spread over four southeastern Florida counties and spanning more than 150 miles. To do this he added four new campuses, new buildings on all the campuses, and many new degree programs, including one in architecture in downtown Ft. Lauderdale. University building projects over the decade amounted to $200 million and included the building of one million square feet of new classroom, laboratory, and office space, and the revitalization of 250,000 square feet through renovation projects.

The new campuses and programs also drew students. During the 1990s the student body more than doubled and by 1999 almost 23,000 students enrolled in FAU classes, making it the fastest growing university in the United States (according to the American Association of State Colleges and Universities). Moreover, Catanese won back most of the former donors and many new supporters were found. He had inherited a $18 million endowment; now he launched the university's first capital campaign and it surpassed its $100 million goal two years before its scheduled end. Donations included two from the Schmidt family that are among the largest contributions ever received by a Florida public institution.

Finally, President Catanese was an athlete who completed a 5-mile run most mornings. He also liked athletics, and believed athletic teams contribute to school spirit and school support. Consequently, he oversaw the move of the FAU athletic teams to NCAA I division status, and led the drive to bring intercollegiate football to FAU in 2001.

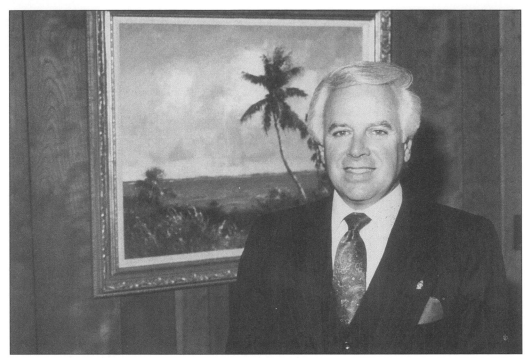

Anthony James Catanese became FAU's fourth president in January 1990. The then 47-year-old educator graduated from Rutgers University in 1963 and earned his doctorate in urban and regional planning in 1969 from the University of Wisconsin-Madison. When he was named president in October 1989, he was serving as dean of the architecture school at the University of Florida.

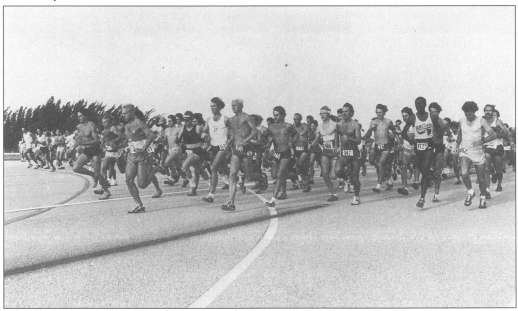

Some of the 500 entrants in the Eleventh Annual FAU Alumni Association Freedom Run of April 4, 1990. FAU's new president participated in the race and placed 60 out of the 500 runners.

102

Through the efforts of the Greater Boca Raton Beach Tax District, the City of Boca Raton, and FAU, vacant land north of the Henderson University School on the FAU campus was turned into soccer fields for the university and the community. President Catanese is seen at the July 24, 1990 dedication and ground-breaking ceremonies.

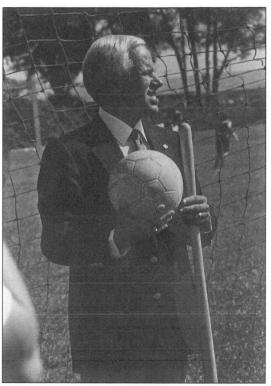

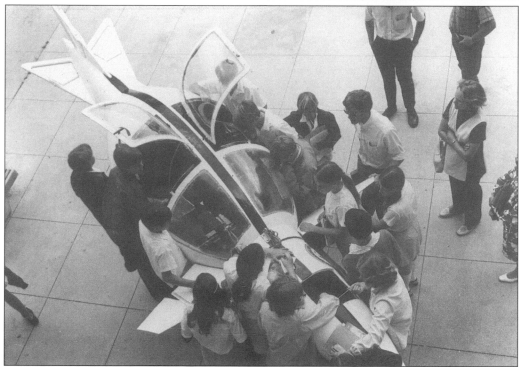

The ocean engineering college's submersible *FAUtilus* created great interest among new students in the fall of 1990.

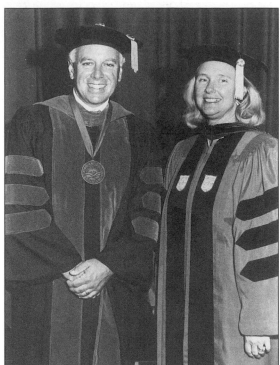

History professor Heather Turner Frazer was named the university's distinguished teacher on October 11, 1990, at the first honors convocation presided over by President Catanese.

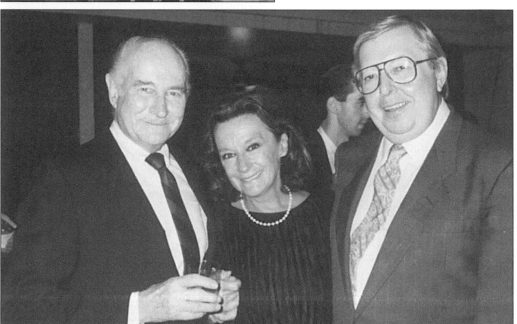

Pictured here are four-time Tony award winner and Schmidt Eminent Scholar Zoe Caldwell with her husband, Broadway producer Robert Whitehead (left), and theatre department chair, Joseph E. Conaway. In 1989 Caldwell performed her acclaimed one-woman show *Come A-Waltzing with Me* before a sold-out audience. A year later, another sold-out audience saw Caldwell and Whitehead in *Love Letters*. Both performances benefitted the theatre scholarship program.

During her five years as Schmidt Eminent Scholar in the Performing Arts, Zoe Caldwell taught master classes for theatre majors and directed several plays. One production was *Dancing at Lughnasa*. The cast and directors from left to right, are as follows: (front) co-director and theatre graduate student William Whitaker, Kari Lubia, Shepard Koster, Leila Piedrafita, and co-director Zoe Caldwell; (back) Carrie Vann, Kathryn Yarman, Jimmy McDermott, Johanna Campbell, and Joseph Bearss.

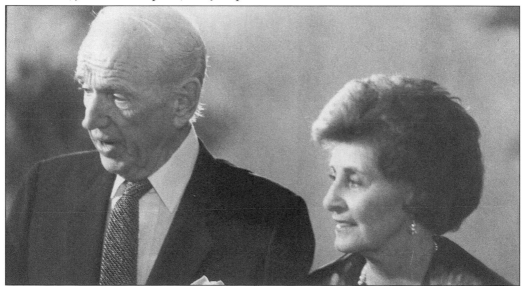

Charles and Dorothy Schmidt came to Boca Raton in 1964. Schmidt had founded the Tractor Supply Company in 1938 in Chicago. The company, a retail chain that distributed farm machinery and repair parts, grew to several hundred branches. In 1975 he began to assemble the Gulfstream banks into a 27-bank holding company. Schmidt sold the banks to NCNB, which today is known as Bank of America. He and Dorothy were among the university's earliest supporters.

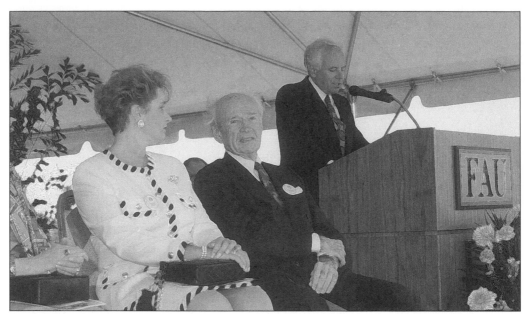

The Schmidts had endowed two eminent scholar chairs and helped create the university's nursing school. After Dorothy's death in 1991, Schmidt gave FAU $10 million to create the Dorothy F. Schmidt Center for the Arts and Humanities in her memory. This gift, which the State of Florida matched, built the three-building, 75,000-square-foot Schmidt complex and endowed two additional eminent scholar chairs. Charles Schmidt is pictured between President Catanese and his second wife, Catherine Schmidt, at the ground-breaking ceremony for the center.

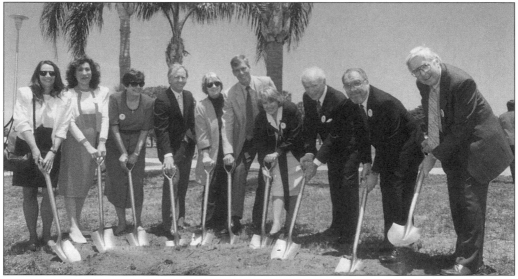

Ground-breaking for the new Dorothy F. Schmidt Center saw department chairs of the college of arts and humanities joining with Charles Schmidt and Dean Sandra Norton in turning the first golden spades of sand. Shown here, from left to right, are the following: Kathleen Russo, Art; Mary Faraci, English; Voncile Smith, Communication; Thomas Baxley, Philosophy; Jan Hokenson, Language and Linguistics; Gary Reichard, History; Dean Norton; Schmidt; Stuart Glazer, Music; and Joseph Conaway, Theatre.

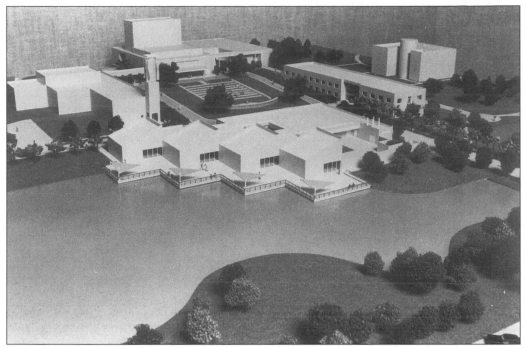

This is an architect's model for the Dorothy F. Schmidt Center, which consisted of three new buildings that formed a quadrangle with the existing humanities building. The new buildings contained a small studio theatre, art gallery, large lecture room, art and photography studios, classrooms, and college offices. Schwab Twitty and Hanser of West Palm Beach designed the new complex.

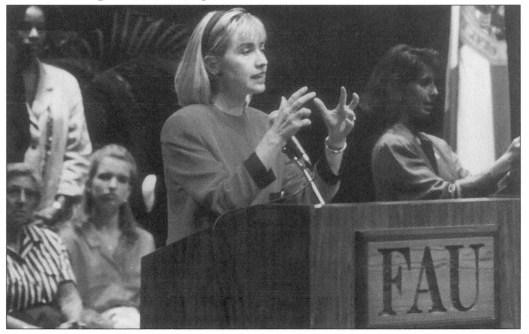

Hilary Rodham Clinton spoke before a large and enthusiastic crowd at the University Center Auditorium during her husband's election campaign in the fall of 1992.

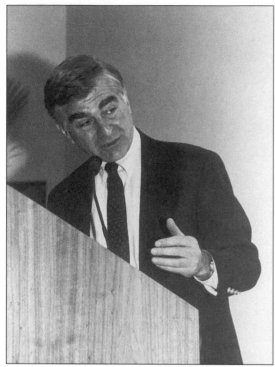

Former Massachusetts governor Michael Dukakis spent several years as a visiting professor of political science during the winter semesters in the early 1990s. His lectures on American politics were extremely popular with members of the Lifelong Learning Society, the successor group of the Society of Older Students.

The Lifelong Learning Society hosted a dinner honoring Michael Dukakis on March 29, 1992. Planning the event are the society's board of advisors. From left to right are Bernie Baker, President Catanese, Claire Carney, board president Rhoda Holop, and Arthur Schlacter.

The FAU chamber soloists, sponsored by the liberal arts college in Davie and made up of FAU and University of Miami faculty and members of the Florida Philharmonic Orchestra, gave a series of eight concerts during the 1993–94 season. Shown here, from left to right, are the following: (seated) cellist David Cole and violinist Carol Cole; (standing) classical guitarist Kenneth Keaton, soprano Judith Drew, pianists and co-directors Judith Burganger and Leonid Treer, soprano Kimberly Bjork, and Lucas Drew on the bass.

Tom Brokaw, anchor and managing editor of *NBC Nightly News with Tom Brokaw,* spoke at the December 16, 1994 Commencement and received the doctor of humane letters degree.

Holding the eminent scholar's chair in science, given in honor of Glenwood and Martha Creech, J.A. Scott Kelso is also both professor of psychology and director of the Center for Complex Systems.

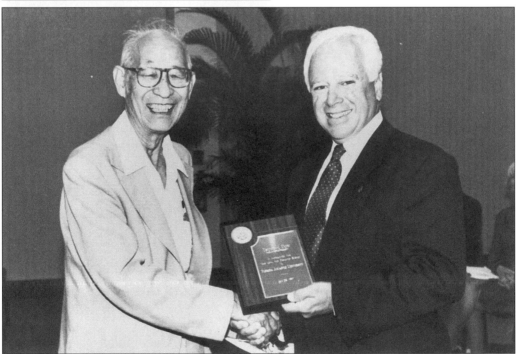

At the 1997 awards ceremony, Tsung-i Dow received recognition from President Catanese for his 30-years service as professor of Chinese and Eastern Asian history at FAU. Dow had become widely known when he played Wong in the movie *Caddy Shack*.

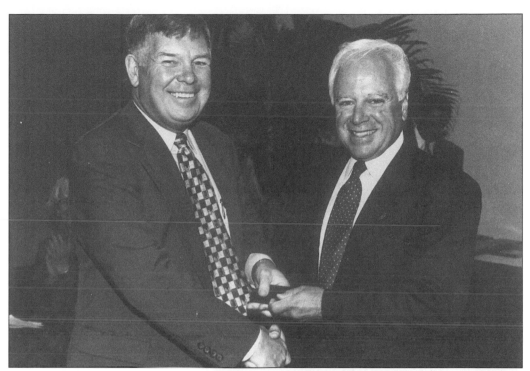

Provost Richard L. Osburn also received recognition from President Catanese at the 1997 ceremony.

In 1979 Eugene Lynn, chairman of the Lynn Insurance group, gave FAU $600,000 matched by a $400,000 grant from the State of Florida to fund an eminent scholar's chair in business. In 1983 he gave a second eminent scholar's chair in nursing in honor of his wife, Christine, a licensed nurse. The Lynns were also extremely generous to the College of Boca Raton, donating $7.5 million for library and dormitory improvements and giving other gifts over the years. In 1991, the college honored the Lynns by changing its name to Lynn University.

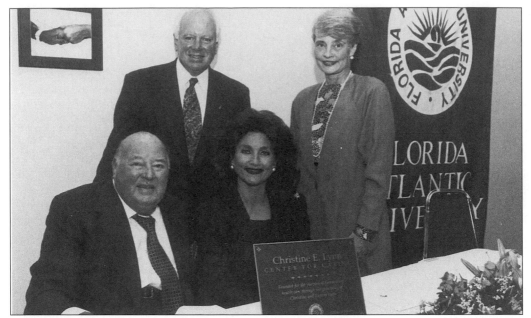

Christine E. Lynn was born in Denmark and received her nursing degree from an institution in Oslo. Although Lynn University had been named for the Lynns, Christine's continued interest in nursing and the mission of the Center for Caring, convinced the Lynns to continue their support for FAU's nursing college. Pictured at the dedication of the Center for Caring are the following, from left to right: (seated) Eugene and Christine Lynn; (standing) President Catanese and Anne Boykin, dean of the college.

The dedication on March 23, 1998, of the Christine E. Lynn Center for Caring saw senior nursing student Lisa Chandler thank the Lynns for their $750,000 gift, which will allow nursing students to identify and care for live-alone elderly persons and at-risk students. Florida partially matched the Lynn's gift with an additional $525,000. Shown, from left to right, are Eugene and Christine Lynn, President Catanese, and Chandler.

112

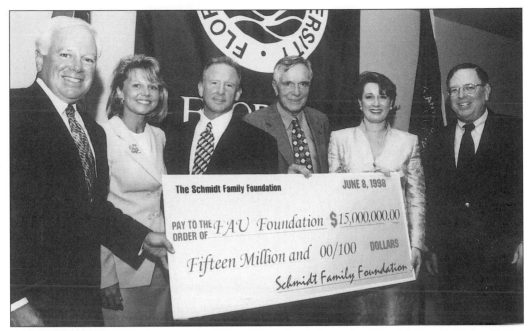

Governor Lawton Chiles accepted a $15 million check from the Schmidt Family Foundation given in memory of Charles Schmidt, who had died in 1996. The gift, matched by the state, was primarily to support FAU's medical education partnership with the University of Miami. It was the largest cash gift ever made to a public university in Florida. Holding the check are, from left to right, President Catanese, Barbara Schmidt, Richard L. Schmidt, Governor Chiles, Catherine Schmidt, and Raymond Webb.

In accepting the $15 million donation from the Schmidt Family Foundation, Governor Lawton Chiles said, "Chuck liked to live large and to give large. This [gift] shows he is still continuing to give...." With this gift, the Schmidts had contributed a total of $27 million to the university, which with the state of Florida's fund matching produced $53 million. Governor Chiles is at the podium and to his left are members of the Schmidt family, directors of their foundation, and President Catanese.

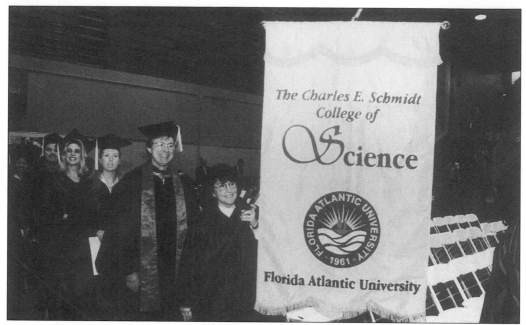

The new banner proclaiming the Charles E. Schmidt College of Science first led graduates into the December 11, 1998 Commencement. Geography professor Ronald Schultz is marshall for the students earning undergraduate degrees.

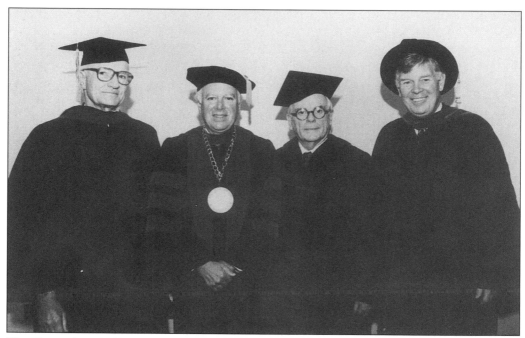

The December 1998 Commencement platform party included author Dominick Dunne, cited as the "chronicler of the powerful and notorious," and Daniel B. Weppner, an education professor for 25 years who on retirement founded the campus volunteer center. Pictured here, from left to right, are Daniel Weppner, President Catanese, Dunne, and Provost Richard Osburn.

On June 2, 1999, FAU signed a partnership agreement with Hebrew College in Brookline, MA, to participate in faculty and students exchanges and to share internet courses in Jewish studies. Signing the agreement, from left to right, are President Catanese, President David M. Gordis (Hebrew College), and Alan Berger (Raddock Family Eminent Scholar in Holocaust Studies).

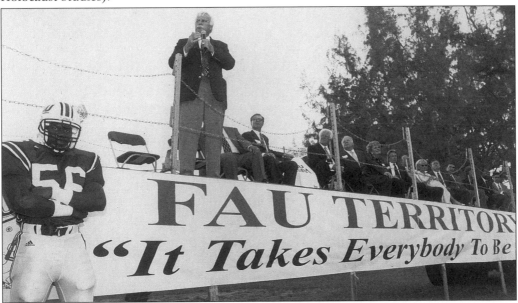

Howard Schnellenberger became FAU's first football coach on July 12, 1999. After 16 months as director of football, during which time he raised $8 million for the program, President Catanese said he had never considered anyone else besides the former University of Miami coach for the position. Schnellenberger is seen here at the Oxley Center ground-breaking where FAU students modeled the Owls' proposed red, white, and blue uniforms.

Thomas E. Oxley speaks during the ground-breaking ceremonies on September 29, 1999, for the Tom Oxley Athletic Center to be built on the western edge of the FAU campus. Oxley, a 1966 FAU graduate and president of the Royal Palm Polo Club in Boca Raton, contributed $4 million to build the 60,000-square-foot facility designed to serve 300 men and women athletes equally.

At FAU's first-ever football pep rally and bonfire, the Methodist church choir sang Handel's "Hallelujah Chorus" and Howard Schnellenberger stirred up the enthusiastic gymnasium crowd. Vice president for university advancement Carla Coleman can be seen on the first row, fifth from the left, with Boca Raton mayor Carol Hanson four places to the right. Directly behind the mayor are Sara and Tony Catanese.

116

Preparing to light the bonfire at the rally, Howard Schnellenberger came to FAU in the spring of 1998 as director of football after a career that included leading the University of Miami Hurricanes to their first national championship in 1983. The 65-year-old Schnellenberger also had been head coach at the Universities of Louisville and Oklahoma.

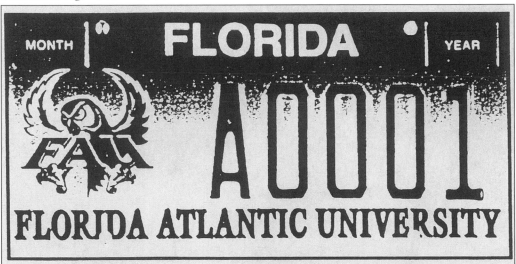

With varsity football only months away, FAU decided to rethink the image created by its sedate and contemplative little burrowing owl. While one newspaper "humorist" suggested a series of "appropriate" southeastern Florida names for the new football team, including the biting sea lice and the plastic surgeons, FAU decided to keep the owl. The new owl, which showed up first as the logo on the FAU license plate, is now the fierce-looking predator created by artist Todd Dawes.

117

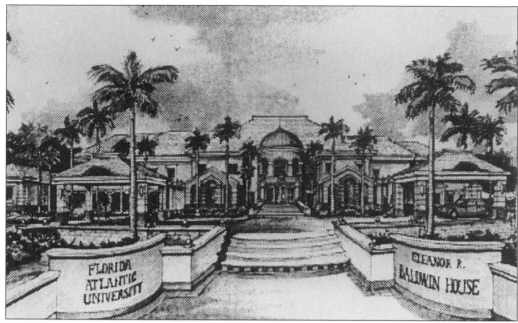

In December 1999, President Catanese announced a $1.5 million gift from Boca Raton philanthropist Eleanor R. Baldwin for a presidential home and university reception center. To be named for the donor, the 14,000-square-foot facility will be constructed at the Twentieth Street entrance to the Boca Raton campus and will provide space for receptions for newly enrolled freshmen, visiting dignitaries, and meetings of the FAU Foundation board.

In 1999, President Catanese said "one of the reasons I almost didn't come here was there were no trees...and I thought if a place doesn't look good, why would you want to go there?" By 1999 there were over 7,000 trees on the Boca Raton campus, most of them the gift of Nicolas and Manuel Diaz of the Homestead-based Manuel Diaz Farms.

The decade of the 1990s saw both extensive landscaping and extensive building on FAU's Boca Raton campus. The 1990–91 academic year saw the opening of the new social science building. This allowed cramped university officials to expand their offices onto the second floor of the now Kenneth R. Williams Administration Building.

The new five-story science and engineering building also opened in 1990.

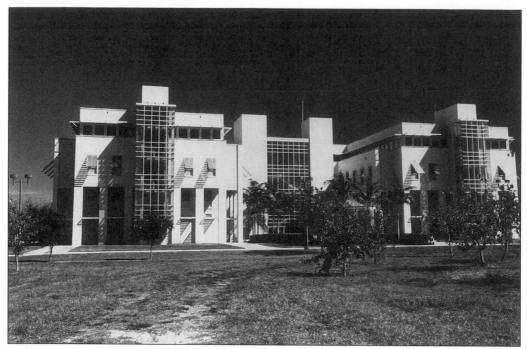

The College of Education building, a $9.2 million project, completed in 1994, contains offices and classrooms for what continues to be one of FAU's largest colleges.

The university formally dedicated the Dorothy F. Schmidt Center for Arts and Humanities on Friday, November 18, 1994, although final construction problems stopped the building from being occupied until the next month. Bells ringing out the changing hours from the bell tower quickly became a new campus tradition.

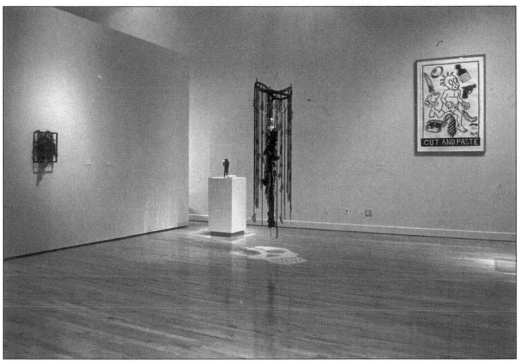

The large new Schmidt Center Gallery provided additional space for exhibitions. Its high ceilings allowed large pieces to be displayed for the first time.

The university located the new physical sciences building between the science and engineering building and the Williams administration building.

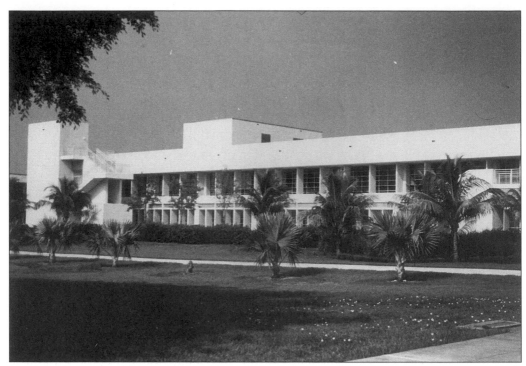

One of the oldest buildings on the Boca Raton campus, general classroom south, received a complete make-over with its obsolete pie-shaped classrooms removed and its open breeze ways enclosed. It opened for classes in the fall of 1998.

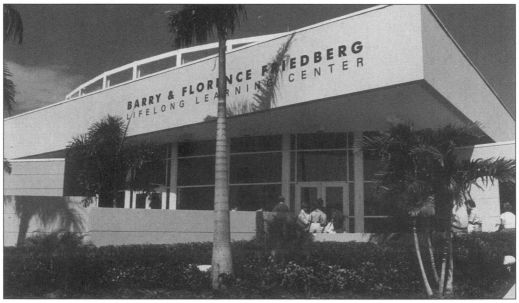

The 1980 Florida legislature allowed people over 60 years old to enroll as auditors in college courses free of charge. FAU immediately formed a Society of Older Students and 250 members enrolled in classes during the first year. Today called the Lifelong Learning Society, in 1999 it completed the Barry and Florence Friedberg Center and served 15,000 men and women, the largest such group in the country.

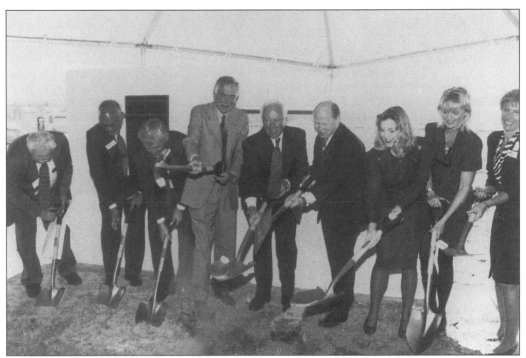

After offering classes in four different north county locations over a 25-year period, FAU finally found a permanent home in Jupiter. Ground-breaking for the new campus took place on February 26, 1998. The three men standing in the center, from left to right, are Governor Lawton Chiles, President Catanese, and FAU alumnus and sheriff of Broward County, Ken Jenne.

FAU vice president for northern campuses Robert Huckshorn cut the ribbon, opening the new MacArthur campus in Jupiter on October 7, 1999. This also happened to be his birthday. Shown here, from left to right, are state university system chancellor Adam Herbert, Paul Lingenfelter of the John D. and Catherine T. MacArthur Foundation, Huckshorn, Jupiter vice mayor Don Daniels, Regent Jon Moyle, and President Catanese.

The "corner stone" of the new John D. MacArthur campus is the Honors College which opened on August 23, 1999, with 79 students. The highly selective college plans to emphasize international and environmental studies.

The Honors College dormitory has suites with private bedrooms wired for phone, cable TV, and the campus Intranet. The 135-acre-campus was donated by the John D. and Catherine T. MacArthur Foundation and is part of the 2,300-acre Abacoa development, which plans to build a city based on the "new urbanism" that incorporates commercial, residential, and educational elements.

For its Treasure Coast campus, In 1995 FAU purchased the $3.5 million facility built by Miami's Barry University. The St. Lucie West location allows FAU to share library facilities with Indian River Community College.

In July 1994 the university completed the $18.5 million liberal arts building in Davie on the main campus of Broward Community College. The university, which had offered classes in Broward County since the early 1970s, now allowed Broward Community College students to complete four years of classes on one campus. By the end of the decade the university also opened the 74,000-square-foot education and science building on the Davie campus.

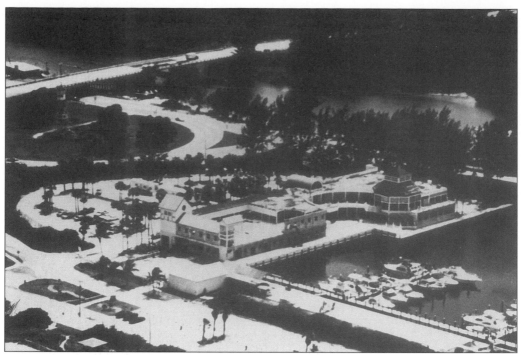

On January 22, 1999 FAU dedicated its $13 million Sea Tech facility located in Dania Beach along the Intracoastal Waterway and just yards away from the Atlantic Ocean as a center for ocean engineering research. In his keynote address, Admiral Paul G. Gaffney, head of the office of Naval Research, told of the Navy's strong partnership with FAU and its commitment of $6 million annually in research funds.

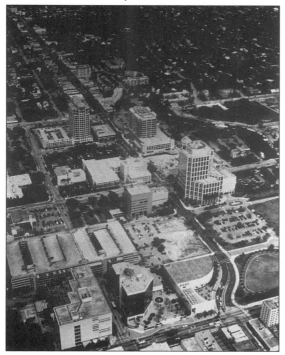

The first university tower in downtown Ft. Lauderdale can be seen at the center of this photograph across the street from the vacant lot that will become the location of the second tower. To the right is the Sun-Sentinel building. The tower is the home of the College of Architecture, Urban, and Public Affairs.

This is Singer Architects' drawing of the second downtown Ft. Lauderdale tower of FAU. The $24.3 million building will allow FAU to expand its downtown course offerings and programs, which already serve 5,000 students at the four Broward locations.

The College of Architecture, Urban, and Public Affairs uses the type of computer graphics that FAU's planners had envisioned 35 years earlier.

BIBLIOGRAPHY

Brumbaugh, A.J. et al. Report to the Planning Commission for a New University at Boca Raton. Tallahassee, FL: Board of Control, June 1961.

Dawson, Robert Charles. "A Study of Florida Atlantic University from July, 1961 to July, 1974." Ph.D. dissertation. Florida State University. 1975.

Miller, Roger H. *The Inside Story: Florida Atlantic University: Its Beginnings and Early Years.* Boca Raton: Florida Atlantic University, 1989.

Singer, Leonard. "FAU: Where Tomorrow Begins." *Audiovisual Instruction* (April 1963): 236–242.

Thompson, Nancine Jane. "The Florida Atlantic University Library and Edward M. Heiliger: An Experiment in Automation (1955–1967)." M.A. thesis. Florida Atlantic University. 1996.

Among President Catanese's other accomplishments was the adoption of a new FAU seal.